IMAGES
of America

SING SING PRISON

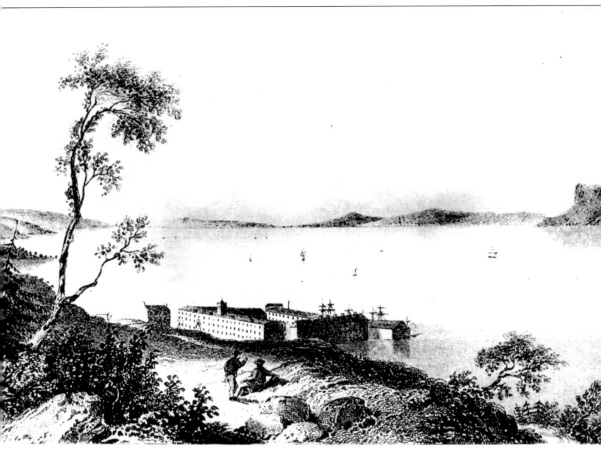

VIEW FROM SING SING.

This drawing of Sing Sing Prison and the Tappan Sea was made *c.* the 1830s.

IMAGES
of America

SING SING PRISON

Guy Cheli
2004

Guy Cheli

ARCADIA

First published 2003
Reprinted in 2003

Published by Arcadia Publishing,
an imprint of Tempus Publishing Inc.
Portsmouth NH, Charleston SC, Chicago,
San Francisco

Printed in Great Britain

Library of Congress Catalog Card Number: 2003106507

For all general information, contact Arcadia Publishing:
Telephone 843-853-2070
Fax 843-853-0044
E-mail sales@arcadiapublishing.com
For customer service and orders:
Toll-free 1-888-313-2665

Visit us on the Internet at www.arcadiapublishing.com

Dedicated with love to my wife, Carol, who greatly helped with her ideas, moral support, and opinions, and to my daughter Deana, who proved to be an expert editor, and to my daughter Jillian, who may be the fastest typist on Earth.

CONTENTS

Acknowledgments 6

Introduction 7

1. Building the Prison 9

2. Early Prison Life 15

3. Warden Lewis Lawes and Prison Reform 59

4. The Rose Man 105

5. The Electric Chair 113

ACKNOWLEDGMENTS

While compiling information for this book, it was my pleasure to make new friends and acquaintances. All the persons listed on this page contributed to the making of this book, and I consider it a privilege to know all of them. I gratefully thank and acknowledge the following people for their contribution to this book.

The Ossining Historical Society supplied a great number of photographs seen in this book. Thanks go to Richard Crisfield, George James Sr., and Fred Starler for supplying important information. A special thank-you goes to Art Wolpinsky for sharing his expert knowledge on Sing Sing Prison with me. Thanks to Michael J. Johnson, who provided the steppingstone that gave me the confidence to complete this project. I thank family members Mary Cheli and Nicholas T. Canosa for their legal advice. My good friend Mike DeVall generously made available his personal collection of rare photographs—thanks, Mike. I thank Kaia R. Motter, my editor, for making this long-distance partnership work. I am honored and humbled that author and historical writer Lincoln Diamant supplied the wonderful introduction found in this book.

I save the best for last, because Roberta Arminio is the best. From the first day I met Roberta, she was supportive of this project. Roberta supplied me with valuable research material and her own knowledge. She made herself available on numerous occasions and was always eager to help. To Roberta I say thank you and you are a friend for life.

INTRODUCTION

As Henry David Thoreau observed after being locked up in the Concord jail for refusing to pay his Mexican War tax, "My night in prison was interesting enough, like traveling into a far country such as I had never expected to behold—a wholly new and rare experience." Like Thoreau, those of us living within the law in Ossining would find a visit to Sing Sing Prison an equally "new and rare experience." Like a sundial measuring only the sunlit hours of a cloudy day, many books present the brightest aspects of urban and suburban life. In this one, however, Guy Cheli has laid out in arresting text and historical illustrations a very realistic view of almost two centuries of Sing Sing Prison life. Every social system finds it necessary to incarcerate individuals who deviate from acceptable social behavior. From the early days of New Amsterdam, with its pillory, ducking stool, and stocks, punishment was more ridicule than condign. As time went by, however, the big city at the mouth of the Hudson River had to grapple with the problem of what to do with its prisons and a mounting number of convicted criminals, including such rogues' gallery daguerreotypes as "murderer," "bunco man," and simply, "sneak." In this sympathetic study, the author traces the history of America's mythic prison—thanks to Hollywood, the most famous prison in the world. The Ossining prison has also remained in the forefront of reform as documented in this book. From the time when prisoners were marched in lockstep from their tiny cells to the Spring Street Quarry to labor all day in all weather for pennies, the state has taken a quantum leap to the prison's present incarnation as the Ossining Correctional Facility. But as a local resident, despite 30-plus years of soporific commuting by rail along the Hudson River, I can still feel a twinge of apprehension as the train slows to stop between the burned-out walls of the old 1828 Sing Sing Prison.

—Lincoln Diamant

One

BUILDING THE PRISON

Built in 1828 as the third prison in New York State, Sing Sing Prison rose from the rocky shores of the Hudson River and eventually became world famous. The first prison in New York, called Newgate, was built in 1797 and was located in Greenwich Village, New York City, near the present-day Christopher Street, also on the shores of the Hudson River. Male and female felons were received at Newgate regardless of their age or the seriousness of the offense. Erected on only four acres and surrounded by massive walls, Newgate contained 54 rooms, each measuring 12 by 28 feet and housing eight prisoners. The women's prison occupied a small, separate wing.

In 1816, a second prison called Auburn State Prison, located well upstate, was built. With Auburn, a new theory of prison administration was put into practice. The Auburn system implemented separate confinement at night and perpetual silence during the day. The prisoners worked in shops during the day and spent the nights in total darkness.

By 1824, Newgate was filled to capacity and Auburn, because of its remote location, could not accommodate the growing number of convicts from the New York City area. It became evident that a new prison would have to be built.

A legislative committee requested Capt. Elam Lynds, the warden of Auburn prison, to assist in planning, choosing the site, and constructing a new prison. Lynds had visited prisons in New Hampshire and Massachusetts where inmates were quarrying stone. He and the commission selected the Silver Mine Farm at Mount Pleasant near the village of Sing Sing. The name Sing Sing was derived from the Native American words *Sint Sinks* (a local tribe), which is a variation of the term *Ossine Ossine*, meaning "stone upon stone." This site, 30 miles north of New York City, offered a quarry that would provide stone for the construction of the prison. Lynds guaranteed that, with the use of inmate labor, he could build a prison at little cost to the state. That March, in 1825, the commission appropriated $20,100 for the purchase of the 130-acre site.

Lynds returned to Auburn and hired architect John Carpenter to draw plans for the new prison, using Auburn's north wing as a model. He selected 100 of his prisoners, loaded them onto barges, and headed toward the Hudson River on the Erie Canal. The prisoners were transferred to freight steamers and sailed down the Hudson River to Sing Sing. These men were

chosen for their brawn, strength, and ability to hew stone. They arrived at the site on May 14, "without a place to receive the inmates or a wall to enclose them." At the moment of their arrival, work began while the muzzles of guns were aimed at the men who toiled in silence. On the first day, a temporary barracks, a cookhouse, blacksmith, and various shops were erected.

By 1826, 60 of the 800 proposed cells were completed after leveling the steep sloping land. By the summer of 1827, 158 men were quarrying stone and working construction. As the quality of the stone on site was found to be inferior, the work progressed slowly and the building was finally completed in October 1828. The completed cellblock measured 476 feet long by 44 feet wide and was four tiers high. Each cell was seven feet deep, three feet three inches wide, and six feet seven inches high.

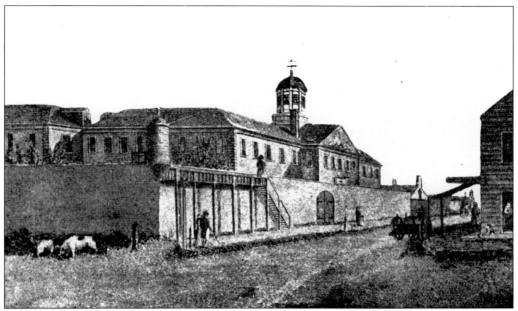

Newgate, named after the prison in London, was the first New York State prison. It was completed on November 7, 1797. In 1828, inmates were removed and sent to the newly opened Mount Pleasant Prison, also known as Sing Sing. With the completion of Sing Sing, Newgate was closed and the property was sold shortly thereafter.

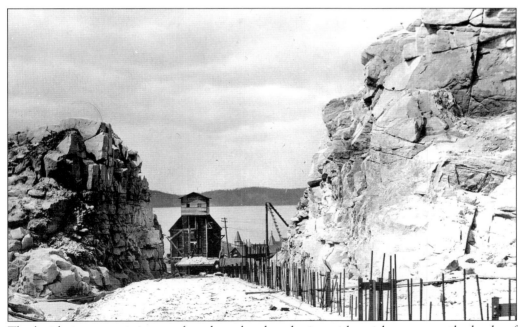

The legislative commission purchased an abandoned mine with a rich quarry on the banks of the Hudson River as the location for Sing Sing. The area was named after the Sint Sink Indians, whose name derives from a term meaning "stone upon stone." Construction began in 1825, and by May 1826, only 170 of the 476 feet of cellblock were complete.

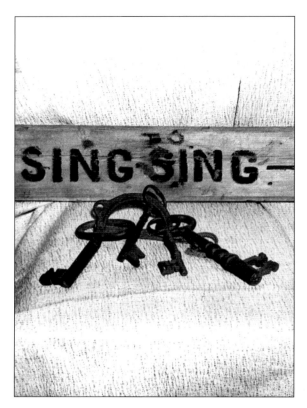

These keys were typical of the ones used in the original cellblock. Invented by an inmate in 1825, the lever-lock system operated on a pulley system that moved a 150-foot bar across the top of the cells. This system enabled the keeper to open and close 50 cells at a time.

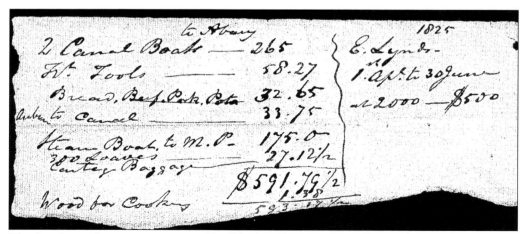

This list shows the expenses incurred by Warden Elam Lynds on the trip from Auburn to Sing Sing on April 1, 1825.

In Senate,

January 17, 1827.

REPORT

From the Commissioners for building a New Prison at Sing-Sing.

TO THE HONOURABLE THE LEGISLATURE OF THE STATE OF NEW-YORK.

The commissioners appointed by the act entitled "An act authorising the erection of a state prison in the first or second senate districts of this state, and for other purposes," passed the 7th day of March, 1825,

RESPECTFULLY REPORT:

That in their report of 20th January last, will be found a specific and detailed account of their proceedings and expenditures to the 31st day of December then last past. The expenditures had been, to that time,

First—For real estate purchased,		$20,156 50
Second—For building materials, transportation and support of the convicts, salaries of officers, and all expenses excepting for services of the commissioners,		18,458 08
		38,614 58
Leaving an inventory of articles not then worked into the building, to the amount of..................	$6880 85	
To which might have been added the real estate purchased,..............................	20,156 50	
		27,037 35
Leaving the actual expenses, exclusive of real estate,		$11,577 23

Of the monies drawn from the treasury for the past year, there remained in the hands of the agent on settlement, 31st December 1825, a balance of......	1 83	
Invoice of provisions, 31st December 1825, sold to ration contractor,	743 94	
A further sum was drawn from the treasury, and placed in his hands, to pay small disbursements, and make a temporary advance to the contractor for rations, of	2000 00	
There has also been drawn orders on the treasury, upon vouchers paid as they were presented by persons who had furnished articles or performed services, to the amount of	22,143 44	
		24,889 21

Shown here is the report to the legislative committee from the commission authorizing the building of Sing Sing Prison.

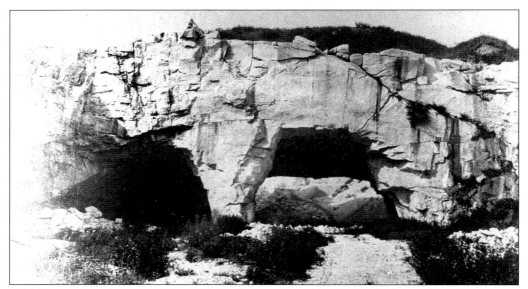

Within months of commencing work in the on-site quarry in 1825, the quality of stone was found to be inferior. Although suitable for use, it would take much longer to shape the stone into blocks for construction.

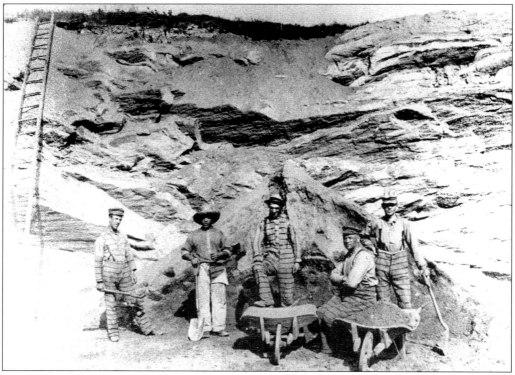

These prisoners at work in the upper stone quarry were transferred inmates from Newgate Prison. They proved to be stubborn, obstinate, and poor workers who did not fit into Lynds's system of discipline.

Two

EARLY PRISON LIFE

As the 1800s progressed, construction at the prison continued. On October 31, 1830, Robert Wiltsie replaced Lynds as warden. Wiltsie ran the prison like a work camp, and strict punishments were administered as Wiltsie deemed necessary.

Additional buildings, including a kitchen and hospital, were built along with a chapel for 900 men. A year later, 200 cells were added with the addition of a fifth tier. By the mid-1850s, with the inmate population over 1,000, yet another expansion was necessary. With this expansion, the cellblock would now stand six tiers high and house more than 1,200 prisoners.

The quarrying of stone continued with inmates working in 10-hour shifts under Warden Wiltsie's supervision. Sing Sing provided stone for sale on the open market, which was used for the courthouse in Troy, city hall in Albany, and the Grace Church on Broadway in New York City. The Printext Building, Highland Court Apartments, and Calvary Baptist Church in Ossining were also built using Sing Sing stone. With the railroads in their infancy, barges on the Hudson River provided transportation for stone being sent north to Albany or south to New York City.

In time, the work done by inmates expanded beyond stone quarrying and inmates began producing boots, shoes, hats, mattresses, and barrels. These items were also sold to the public on the open market, and this practice began many years of inmate contract labor. This system was eventually phased out in the late 1800s because of bitter opposition from labor unions. In 1901, the village of Sing Sing changed its name to Ossining because local merchants did not want their goods associated with merchandise from the nearby prison of the same name.

In 1837, part of the prison was partitioned off for the purpose of receiving female inmates. A separate building containing 81 cells was completed in 1839 to house the female prison population.

Like the male inmates, the women worked long hours while producing such items as hats, clothing, and bedding. The women's population continued to increase, and by 1853 well over 100 women occupied the 81 cells. In 1877, the state began transferring female inmates out of Sing Sing to local jails. By November 1877, the women's cellblock at Sing Sing was abandoned and closed forever.

As the 19th century drew to a close, the rights of inmates and their treatment were viewed in a new way. In 1900, the long-held practice of the lockstep, which involved marching the prisoners while they were shackled together at the ankles, was abolished. Similarly, the wearing of the archetypal striped prison suit was eliminated in 1904. By 1913, inmates were permitted to remain out of their cells on Sunday for recreation and exercise. Baseball was introduced on the recreation field in 1914 under Warden McCormack.

Warden Thomas Mott Osborne continued this direction of prison-life reform with the introduction of the Mutual Welfare League. This was a self-governed organization among prisoners that consisted of an executive board, several delegates, and a court with seven judges. The prison administration and the league work together to hear grievances and mutually enforce the prison rules.

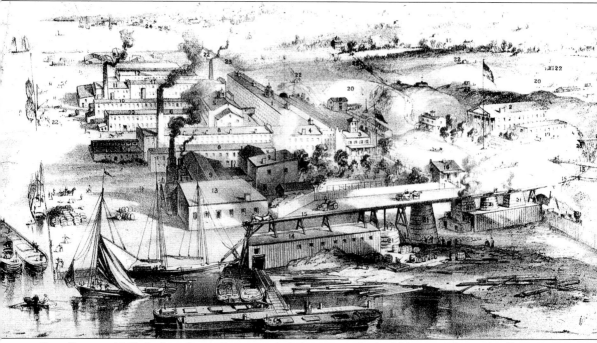

Sing Sing in 1868, before the wall surrounded the prison, looked like an industrial village on the banks of the Hudson River. Most inmates worked in the stone quarry or were employed in the various industrial shops. A good number of men cut and hauled stone to be shipped out to the open market on barges that traveled the Hudson River.

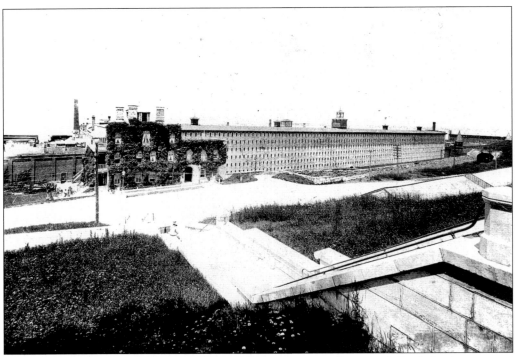

This *c.* 1880 photograph shows a glimpse of the prison wall to the left of the ivy-covered warden's residence. Notice the darker shade of stone that comprises the two added upper tiers.

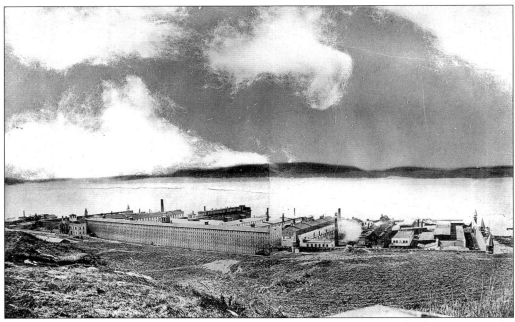

Sing Sing Prison is seen in 1889 with the Hudson River and Palisades in the background. The long stone building in the foreground is the cellblock with the hospital, chapel, mess hall, and various industrial shops behind it.

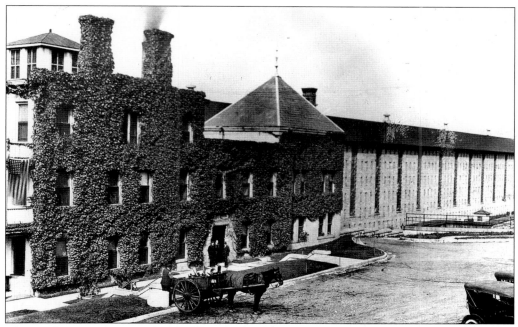

The warden's residence and old cellblock are shown here in the early 1900s. To increase the light inside the cellblock, large windows measuring 31 feet high and 5¹/₂ feet wide were added in 1902.

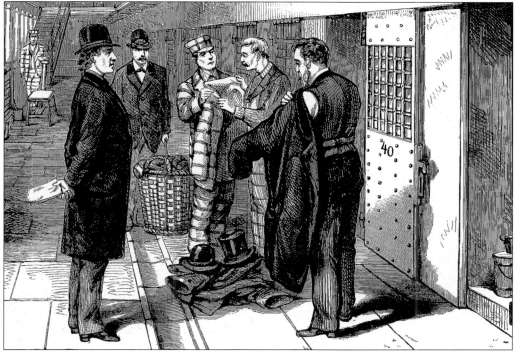

This drawing depicts an inmate's first day at Sing Sing *c.* 1860. The inmate will assume prison garb, be shaved, drilled in marching, and assigned a cell.

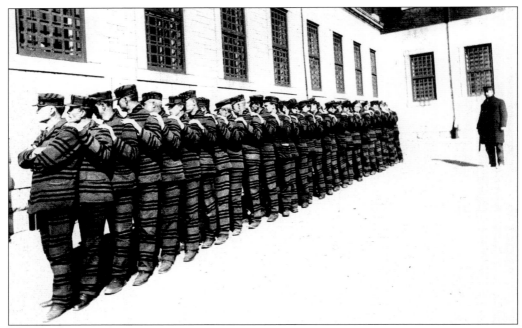

The striped uniform was worn until 1904 with one stripe for the first-time offenders, two stripes for the second offense, and three stripes for third-time offenders. Inmates with four stripes were considered incorrigibles and were called zebras for the many stripes on their uniforms.

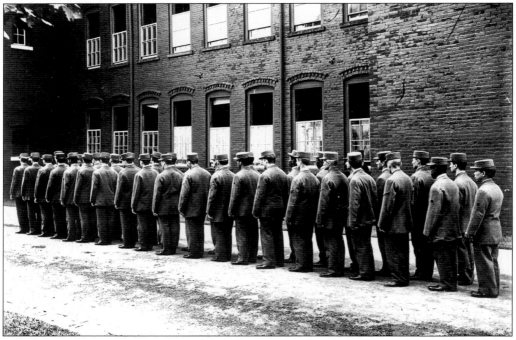

After 1904, the prisoner's uniform changed to a gray color. Administrators expected positive results from this change. Warden Addison Johnson stated that the men were cheerful, and he was confident this would lead to a more positive atmosphere.

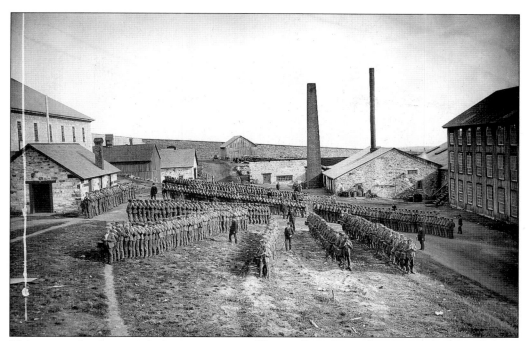

This very early photograph shows inmates at Clinton State Prison lined up in lockstep fashion c. 1860–1870. The lockstep originated at Auburn Prison and was used at Sing Sing until 1900.

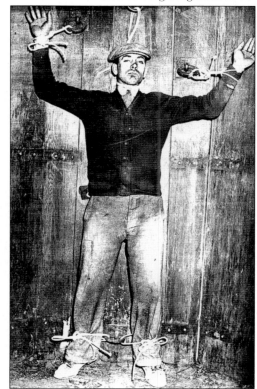

The cat-o'-nine tails was a symbol of authority in 1830 Sing Sing. It was made of long strips of leather that were attached to a wooden handle. Prisoners were flogged or lashed with the "cat" as a form of punishment. By 1848, the use of the cat was eventually eliminated.

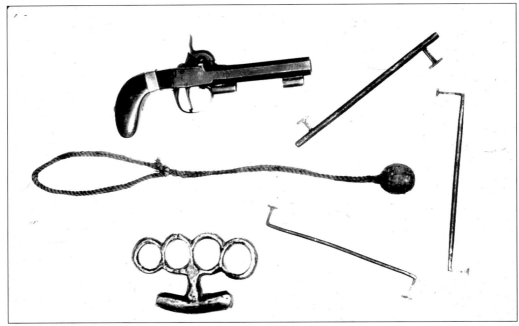

This 1916 photograph shows a pistol, brass knuckles, a bola, and picks for opening locks that were among the items seized from prisoners. Inmates were not frisked for contraband after visits until 1945.

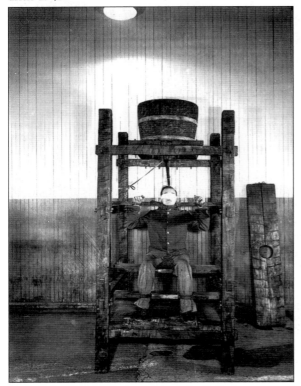

The cold-water shower was a punishment that began in 1848. Inmates staged a deadly riot in 1869 to protest the use of the shower and other forms of punishment. A law was enacted to prohibit the shower's use.

John McAllister, artist and burglar, escaped from Sing Sing on June 12, 1919. This dummy was made of old clothes, clipped hair, bread dough, and a little paint (probably hidden under his bed until the time of use).

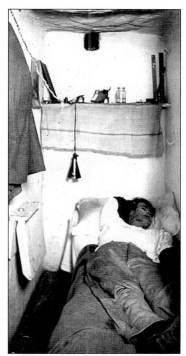

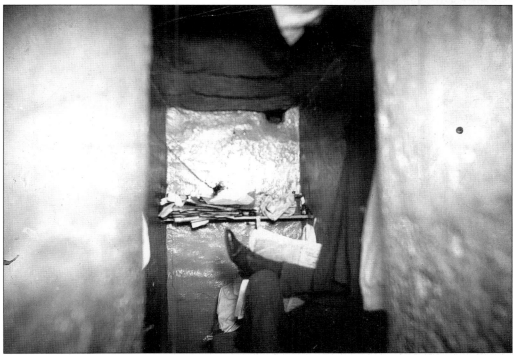

On January 12, 1916, inmate Jean Kirshner escaped from a cell undetected by leaving this dummy in his place. He was captured six weeks later and returned to prison, making several subsequent escape attempts at Sing Sing in Clinton Prison.

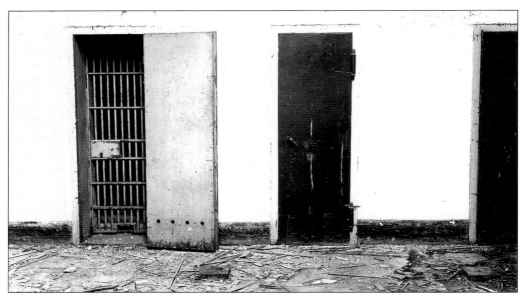

During the 1800s, completely dark cells were used as a form of punishment. An average of 100 men per year were placed in these cells for varying amounts of time.

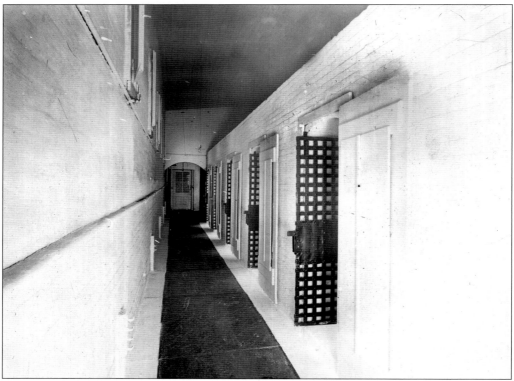

In 1879, a structure containing 10 dark cells for solitary confinement was built. It stood in the yard, separate from other buildings, and each cell was well ventilated and had a supply of fresh water.

The use of dark cells was discontinued in 1914; authorities viewed the practice as unhealthy.

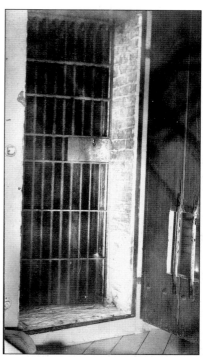

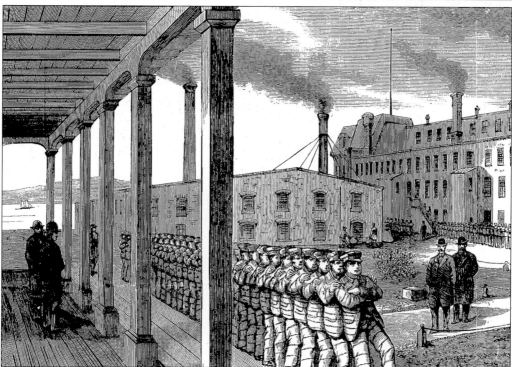

This 1860s scene shows a group of new inmates marching to a workshop. The prison was paid a fee, of which the inmates earned pennies for labor provided to civilian contractors.

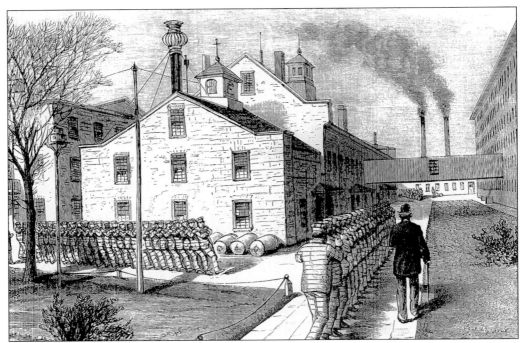

This sketch accurately portrays the landscape of Sing Sing during the 1800s. These prison gangs are marching in lockstep fashion to the noontime meal.

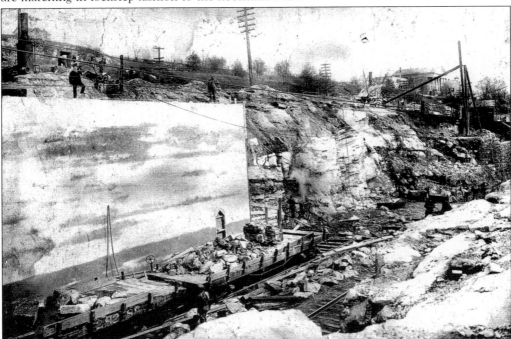

By 1830, inmate labor was quarrying marble and granite for sale on the open market. Numerous contracts for such stone were made with New York City and other cities, but these contracts were terminated around the turn of the century owing to pressure from labor unions.

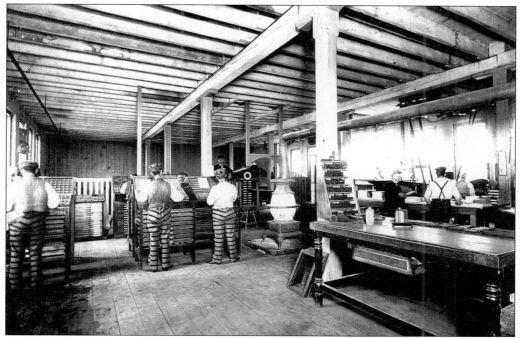

Inmates shown here in this c. 1890s image were still under the rule of absolute silence. The keeper observes while a civilian contractor inspects the goods produced by prisoners.

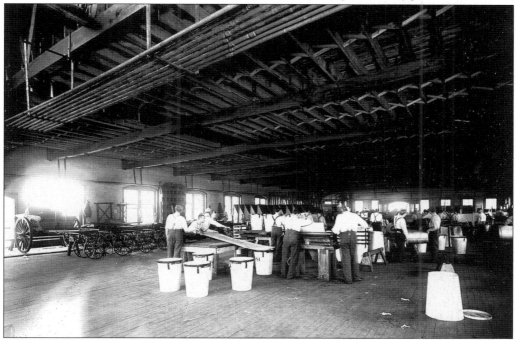

In the mid-1800s, horse-drawn wagons and sleds that included beautiful, hand-painted scenes on their surfaces were manufactured by inmates at Sing Sing. There are still some of these rare and prized possessions in existence today.

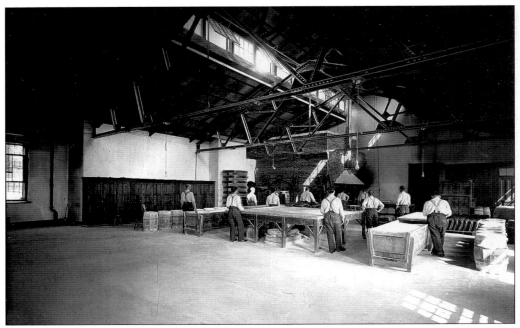

The cleanliness of this room is evident in this *c.* 1905 photograph of the prison bakery. Bread for every meal was baked in the huge ovens seen in the center of the image.

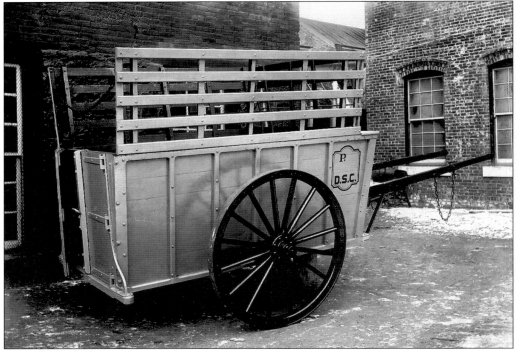

This horse-drawn cart was used for street-cleaning duty within the prison walls. The initials for the Department of Street Cleaning were attached by inmates who assembled the cart in the wagon shop *c.* 1880.

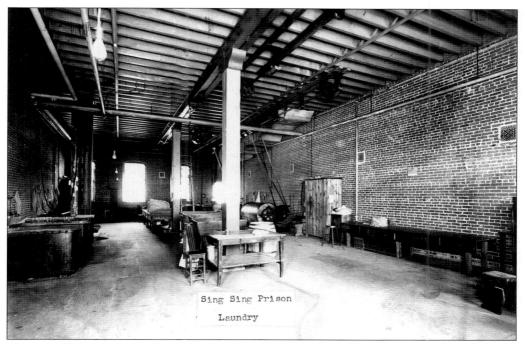

This *c.* 1895 image shows the prison laundry, where much of the washing was done by hand. Each inmate at Sing Sing received a clean uniform twice each month.

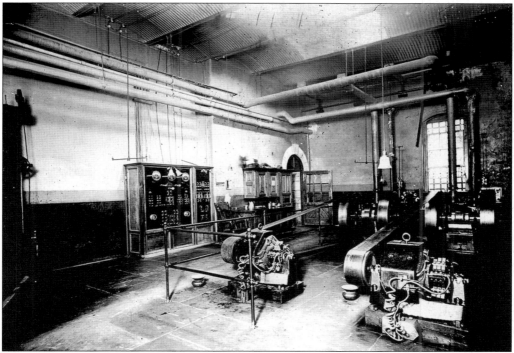

The power room, seen here *c.* 1900, contained two dynamos that generated electricity converted from coal. These generators provided electricity to the entire prison.

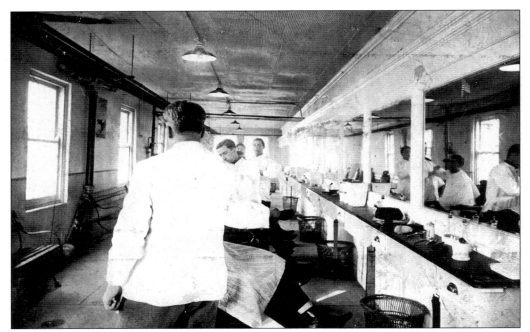

Seen here in 1918 is the Sing Sing vocational barber school. Inmates received haircuts twice a month and a weekly shave by competent barbers. An inmate expecting a visitor or meeting with attorneys would get a special shave.

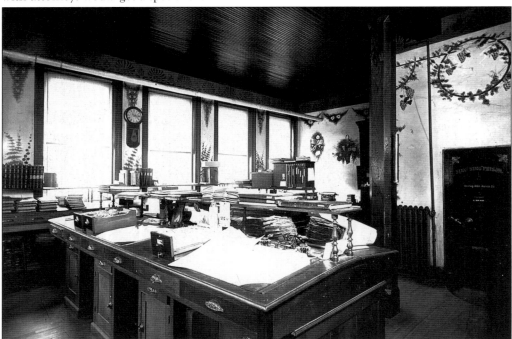

The Identification Clerks Office is shown c. 1890. Inmates were identified by means of a photograph and the Bertillion method, which was a way of identifying inmates by measuring their head, arms, eyes, feet, and so on and recording the results.

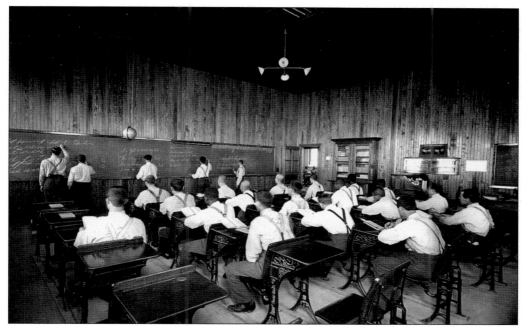

By the late 1800s, a large percentage of inmates were still illiterate. Prisoners attended school to learn to read and write for one hour a day. The teaching was undertaken by a prison instructor who was supervised by a civilian head teacher.

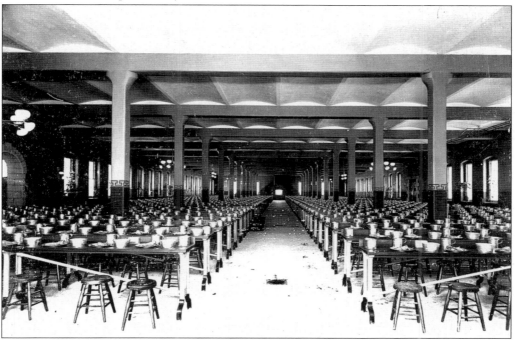

This 1890 photograph shows the old mess hall. The tin cups, plates, bowls, and utensils were made in the sheet metal shop by inmates. The mess hall was located on the first floor and the chapel was directly above it in the same building.

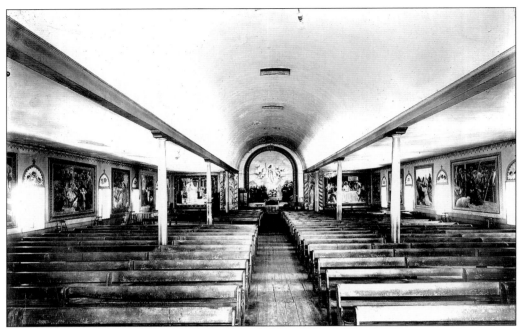

The original chapel was built in 1828 and could hold 900 men. Most inmates were religious and believed in God, but church attendance was irregular in the early days, as no inmate was compelled to attend services.

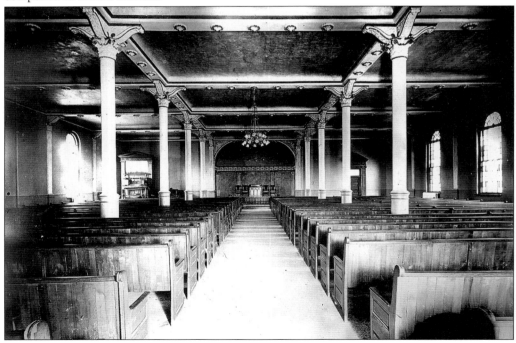

The chapel was remodeled c. 1880. Stained-glass windows were added, and the altar was adapted to all faiths. Before 1880, chaplains had been visiting the prison, and by 1900 these visits were on a regular basis. In 1913, an associate chaplain was appointed for the first time.

This old tracker organ was used in the chapel during services. Much of the intricate woodwork was handcrafted by the inmates c. 1880. Prisoners were permitted to play the organ at chapel services during early prison years.

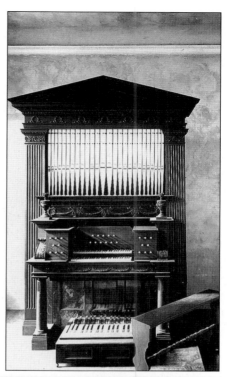

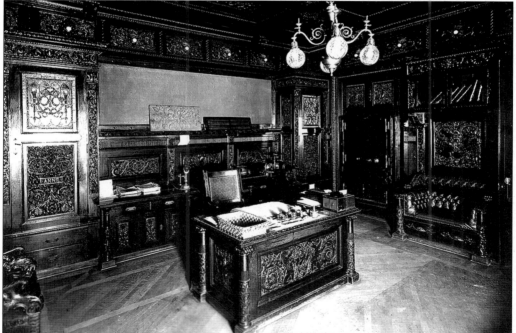

The warden's business office, shown here as the old residence, was probably the most ornate working space of any public official. The elaborate woodwork and ceiling ornamentation were carved by an inmate in 1907.

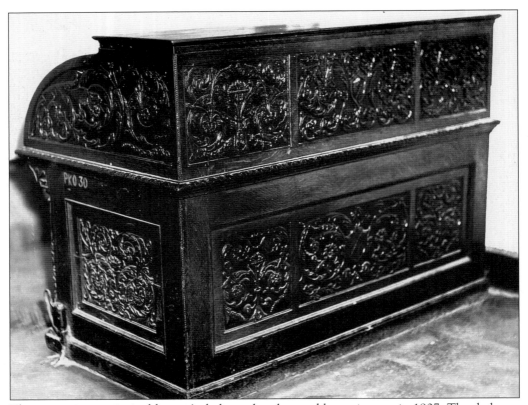

This very ornate principal keeper's desk was hand carved by an inmate in 1907. The desk was still in use as a duty officer's desk in the 1960s.

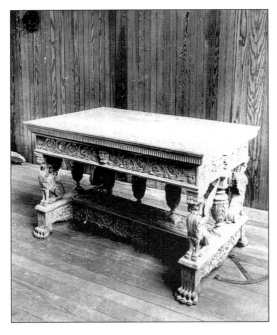

The warden's reading desk was hand carved by an inmate c. 1915. The skillful hands of inmates made much of the fine wood furniture in the prison.

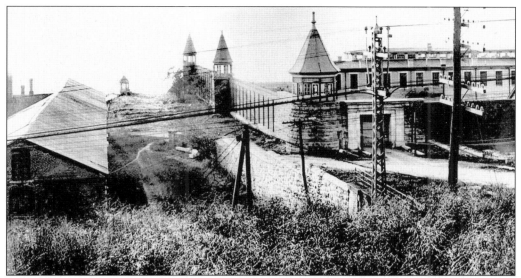

Facing west, this photograph shows guard posts four, five, and six c. 1890. The guard towers of the old prison had more steeply pitched roofs, while the towers used today are designed to provide increased comfort for the guards.

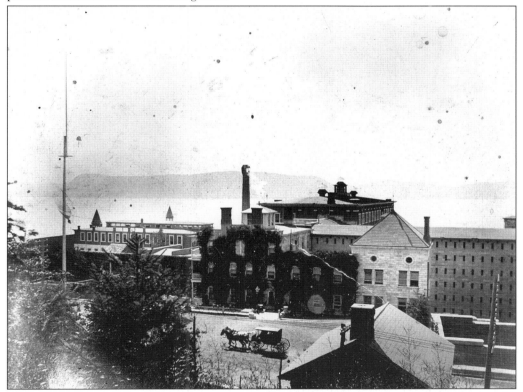

This image shows a view of the old prison in the late 1890s. Pictured, from left to right, are the bakery and tailor shop, the warden's residence, the hospital, the administration building, and the cellblock. In the foreground is the prison's on-site fire department.

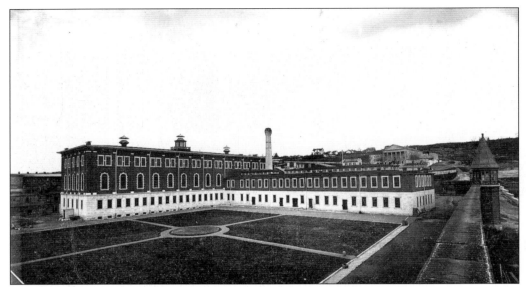

Facing east, this photograph shows the administration building *c.* 1900. The recreation yard is shown in the foreground, and the prison wall, built in 1877, is on the right. The building with the columns on the hill is the women's prison, which operated until 1877.

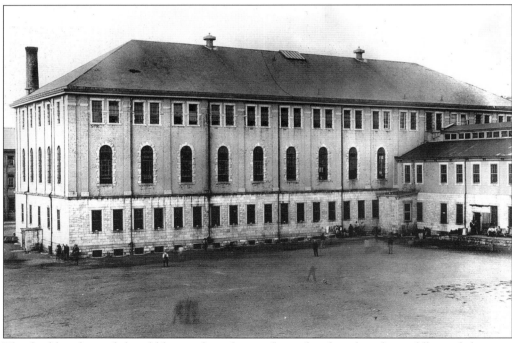

This building housed the old hospital on the top floor, the chapel in the middle, and the mess hall on the ground floor. The building was vacated by the 1930s for new quarters at the new prison on the hill.

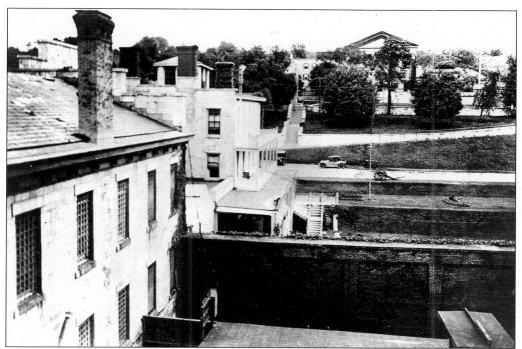

Looking east *c.* 1915, this view of the old warden's residence includes automobiles of the era. The old women's prison can be seen behind the trees in the area where the new prison would eventually be built.

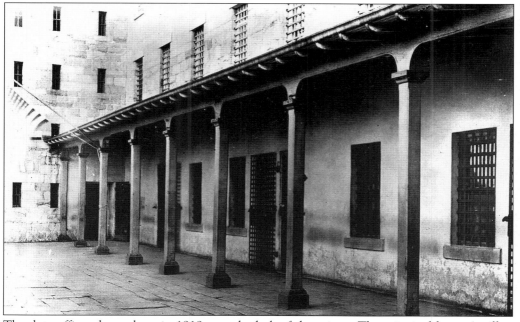

The duty office, shown here in 1919, was the hub of the prison. The principal keeper's office was located here along with the prisoners' court. If an inmate was charged with an infraction, his case would be heard here.

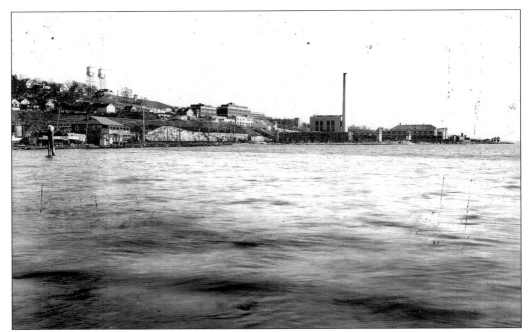

Beginning in the mid-1800s, boats brought supplies to the prison, and goods produced in the shops were sent out. The prison's industrial shops were located near the waterfront for easy loading onto barges of the many goods made there.

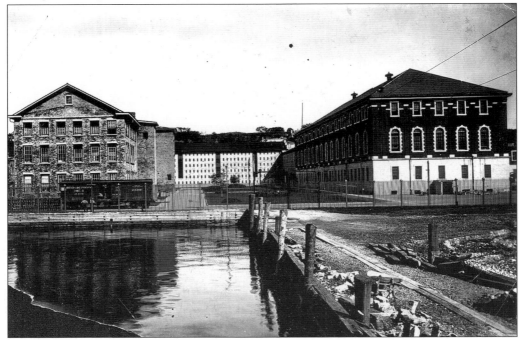

A factory on the left, an old cellblock in the center, and the old hospital on the right are shown from the waterfront c. 1903. Inmates were permitted to cast fishing lines over the fence as a form of recreation in the early teens.

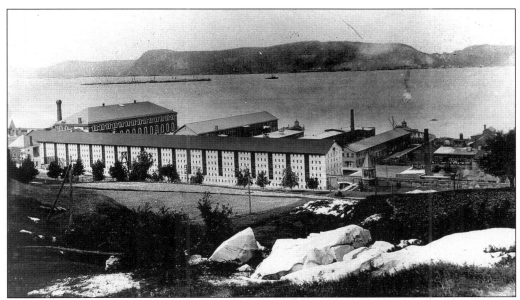

The old prison was built by the water's edge for two reasons. First, the importance of having the workshops at the riverfront was to facilitate the shipping of stone and other goods from the site. Second, there was an importance of securing a site with proper drainage facilities. The location of the cellblock proved too low (only a few inches above water level), which resulted in poor ventilation and damp cells.

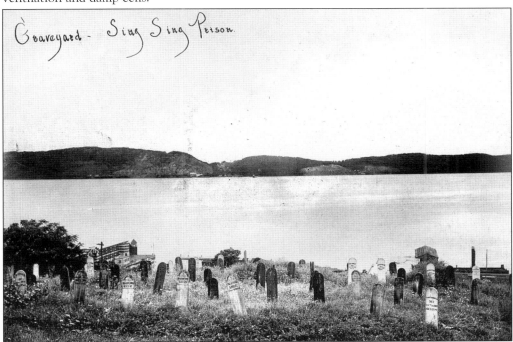

The cemetery at Sing Sing was called Gallery 25. Located on a sunny hillside overlooking the river, it was the resting place for those who were unclaimed. The bodies were disinterred and taken to local cemeteries by the 1940s, when the new prison complex was completed.

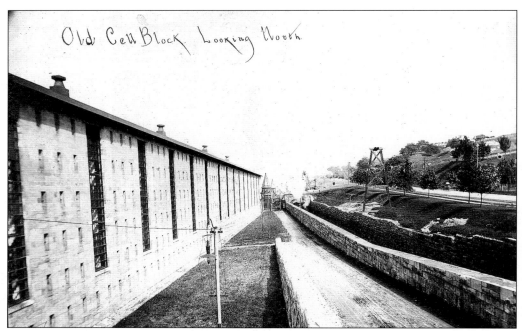

Facing north, this c. 1915 photograph shows the old cellblock. The new prison complex will occupy the hillside on the right of this photograph. The large, vertical windows, added in 1902, are visible in this picture.

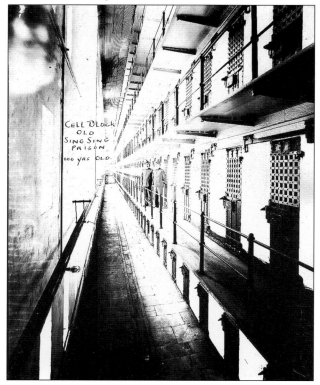

The iron doors of the old cellblock were set flush with the corridor instead of being recessed 21 inches at the inner ends as planned. They were built this way in 1825, and a prisoner could increase his walk from two and a half to three steps while pacing in his cell. Prisoners fitted with a ball and chain would roll the ball along the water trough seen in the center of the lower hallway.

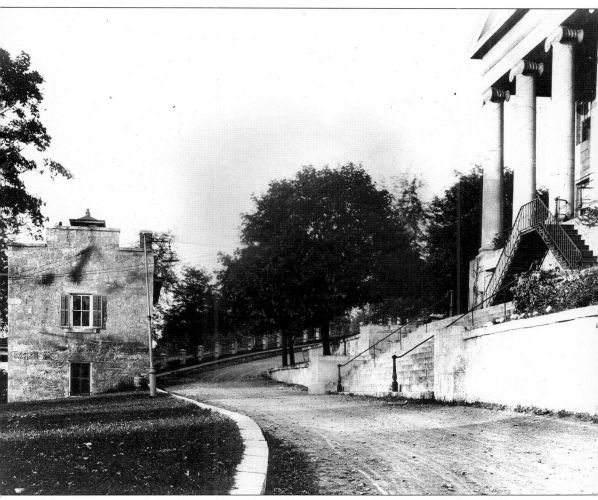

The women's prison began housing female inmates in 1839. With its great columns and intricate stone work, this building stood out from the other stark, cold structures at Sing Sing. The guardhouse and armory are seen on the left in this photograph. By 1877, all of the women prisoners were transferred to Kings County Penitentiary and the facility was closed. The women's prison was demolished in 1927 to make room for the new chapel and assembly building.

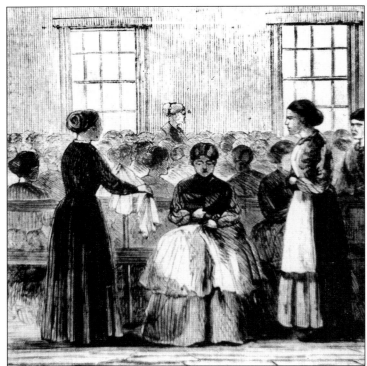

The first matron of the women's prison at Sing Sing was Miss Bard. During this time, the prison was overcrowded and the inmates were rebellious. While there were no provisions for teaching the women inmates at first, in 1847 the state authorized the hiring of teachers to instruct the women in common English and basic studies.

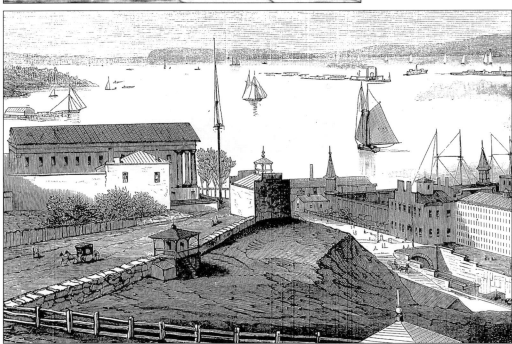

This scene shows the prison as it looked in the 1870s, with the women's prison standing at the top of the hill on the left. The stonecutting shops and cellblock are located behind the railroad tunnel on the lower right.

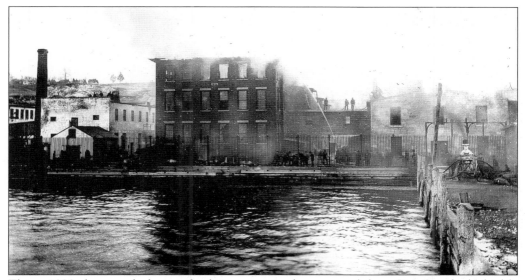

This c. 1880 photograph shows a fire being contained to one workshop. Sing Sing had a highly rated, well-trained fire department, and there was never a shortage of volunteers among the inmates. Notice the early fire apparatus on the right side of this picture.

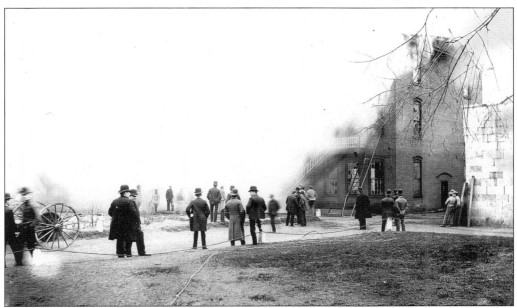

A fire is shown consuming one of the industrial shops c. 1880 in this photograph. Built of brick-and-wood construction and heated with wood and coal-burning stoves, these shops were fire hazards.

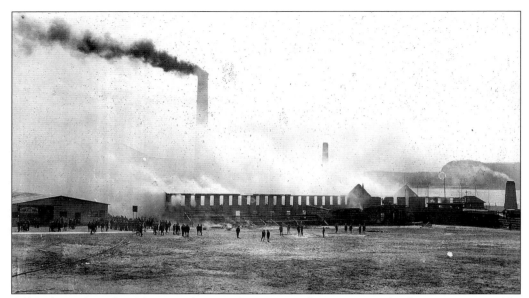

A fire that was set by an inmate destroys the mattress shop in 1914. The fire was contained by the Sing Sing fire department before any further damage could occur.

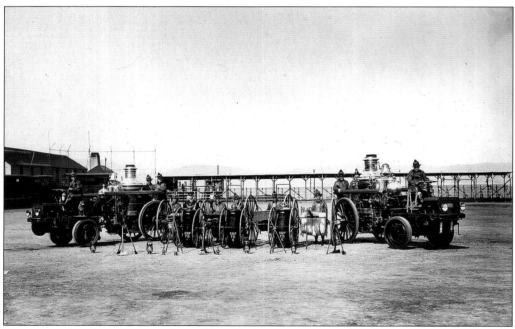

The prison fire department is shown here displaying its equipment. One of the steamer trucks was brought in from the village of Ossining on a mutual-aid basis. These trucks were used from the 1900s through the late 1920s. The manual hose reels belonged to the prison fire department and dated back to the mid-1800s.

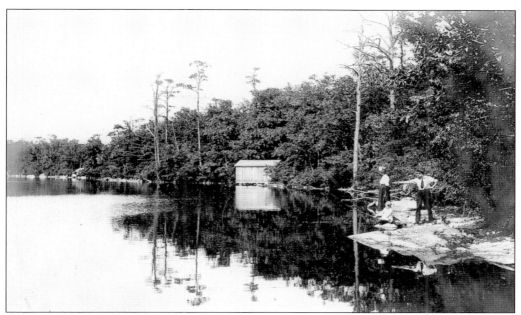

A new Sing Sing was to be built at Bear Mountain near Hession Lake. In 1909, 150 inmates built temporary barracks and cleared the land to ready the site for construction. The plan was abandoned and the site was vacated, with the property becoming part of the Palisades Interstate Park System.

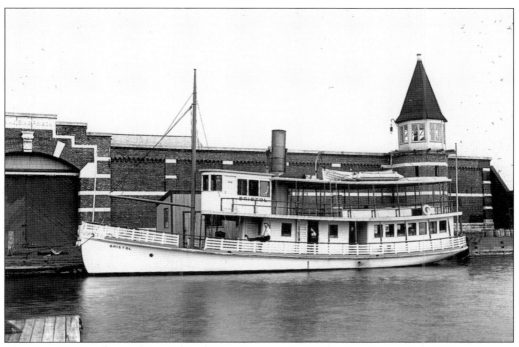

The steamer *Bristol* was chartered and put into service on July 14, 1908. In 1909, inmates were brought up to Bear Mountain and back each day to clear land at the proposed site of a new prison.

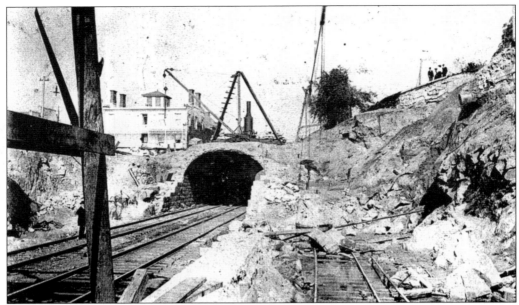

Up until the construction of the railroad bed began in 1848, Sing Sing was accessible from New York City only by slow-moving steamboat or by horse via the Albany Post Road.

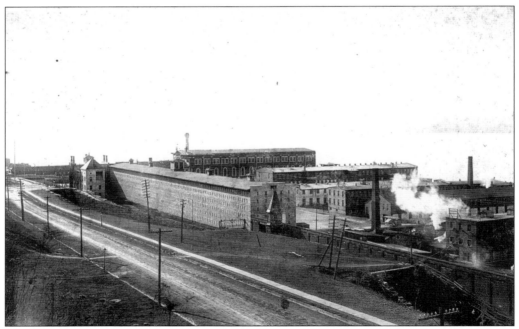

The Lincoln funeral train passed through Sing Sing in 1865. Prison officials were permitted to board the train and view the body of the late president when the train halted to have its water tank refilled.

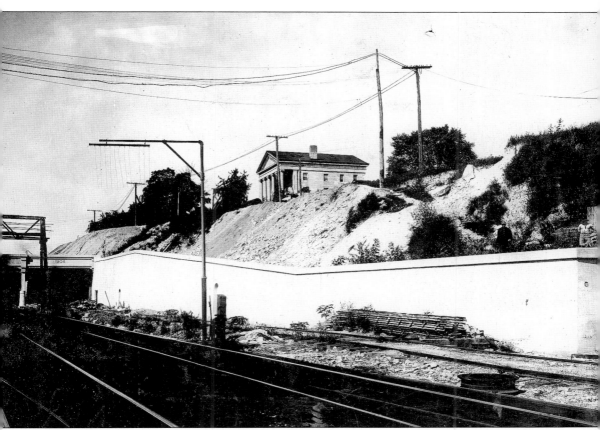

In 1906, the train tunnels and tracks were modified to accept electric-powered trains in place of steam engines. The electrified trains were cleaner, faster, and safer. The women's prison is shown here before being razed to make room for the new prison.

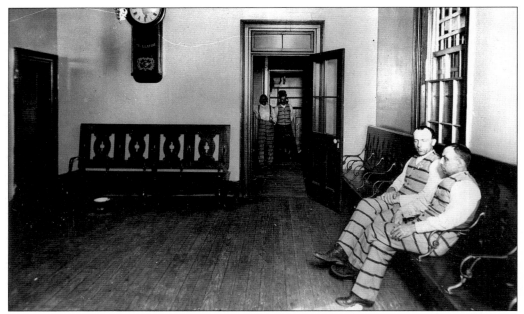

Shown here are first-time offenders prior to 1904 in the old key house. Prisoners waited here to be brought to the administration building to meet with visitors. The first visits were allowed twice a year in 1846. By the early 20th century, inmates were allowed four weekday visits and one Sunday visit per month.

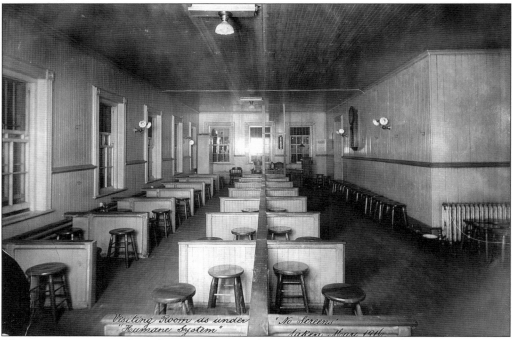

The visiting room at Sing Sing, as seen in this 1916 photograph, had no screen or glass partitions to separate prisoners from their visitors. Screens were added in 1942 to prevent the passing of contraband.

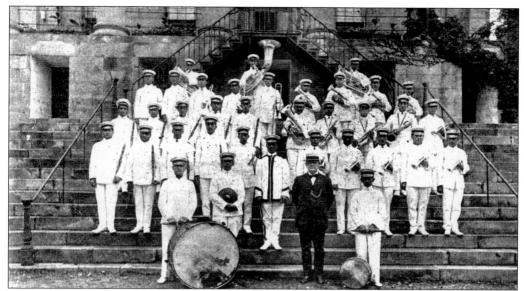

Sing Sing's band is pictured with Warden Moyer on July 4, 1917. The band is physically and musically fit and can match any band with its playing ability.

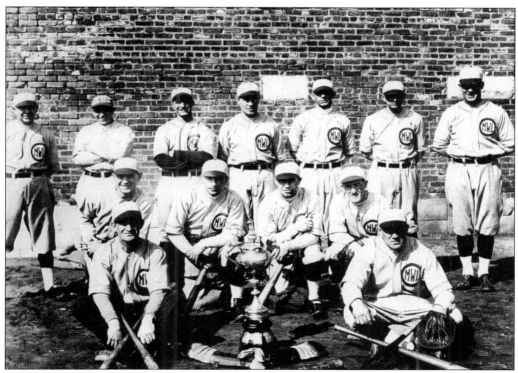

Baseball as a form of recreation started in 1914. From just before 1920 through the 1930s, the New York Yankees and New York Giants would play games against the prison teams. Babe Ruth was a favorite and was known to hit the longest home runs on the prison field.

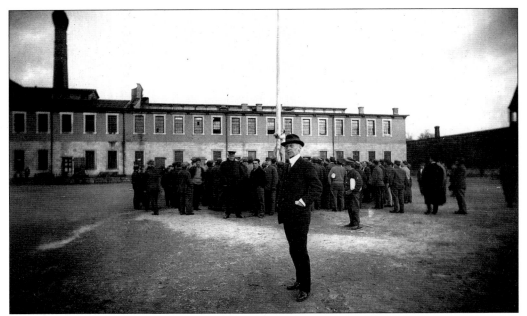

In 1913, Warden James A. Clancy conducted an experiment by allowing prisoners to remain outside their cells in the fresh air on Sunday mornings. The inmates were permitted to stand or sit at ease, and this reform was welcomed by the inmates, who had been previously confined to their cells throughout the weekend.

Warden W.R. Brown held office from May 1891 through May 1893. The building in the center with the columns is the women's prison. To the right is the clothing shop, and on the left is the guardhouse and armory.

Dr. Amos O. Squire was associated with Sing Sing from 1900 until 1925. As chief physician from 1915 until 1925, Dr. Squire was an early proponent of prison reform and was staunchly against the death penalty.

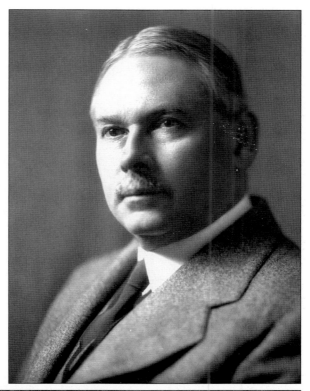

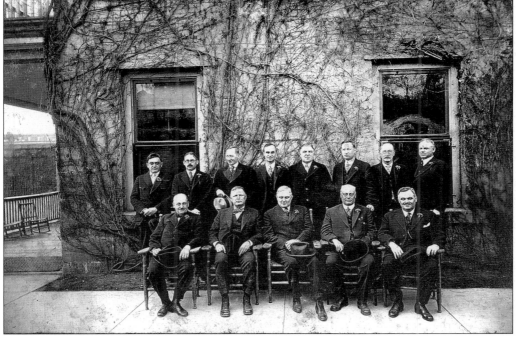

Warden William H. Moyer, seated second from the left, is shown here with a group of visiting state dignitaries. Chief Physician Amos O. Squire is standing second from the left in this 1916 view.

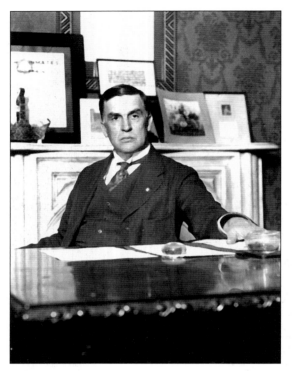

Warden Thomas Mott Osborne, shown here on August 31, 1915, led the way toward the new penology. He was a sincere advocate of prison reform and used the press to introduce the prison to the public.

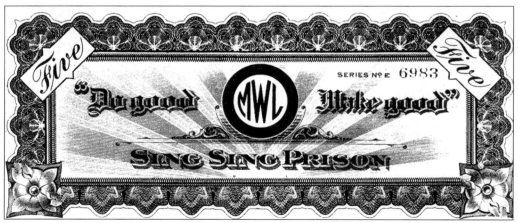

The Mutual Welfare League was founded by Warden Osborne in 1914. Shown here is the currency used within the prison at the two stores opened by the league in 1919. One store sold groceries, and inmates could spend up to $6; the second store sold cigarettes and candy with a $3 limit. The stores were eliminated in 1937 because of a ruling prohibiting paid transactions on state property.

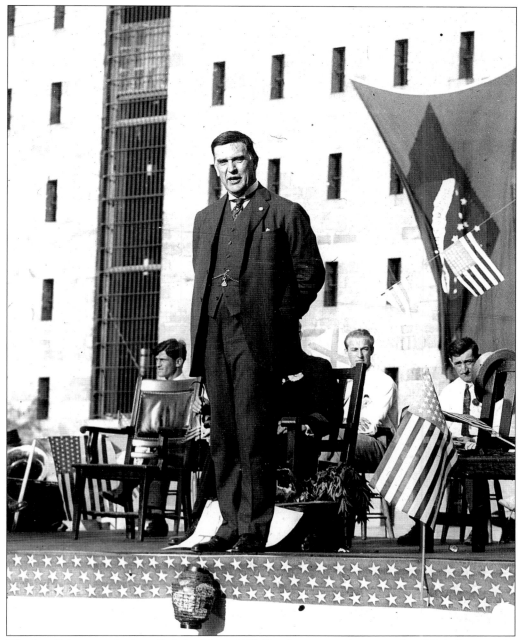

Warden Osborne, who installed the Mutual Welfare League, is shown in this 1914 photograph. As part of the Mutual Welfare League, which Osborne helped initiate, the inmate organization would write and enforce their own prison rules. Living by his motto, "Do good, make good," Osborne believed if he trusted the inmates, they would be trustworthy. Accused of coddling prisoners by Superintendent of Prisons James B. Reilly, Osborne resigned after a leave of absence in 1916.

This letter shows the respect prisoners had for Warden Addison Johnson, an early proponent of prison reform. During his term (1899–1907), the first prison newspaper was printed and the parole system was established. Johnson also lobbied to have the striped uniform and the lockstep abolished.

Sing Sing Prison
December 25th 190_

My dear Warden

Accept my heartfelt thanks for your kindness in sending a Christmas present, which was a glad surprise to one whose many years of imprisonment has deprived of nearly every human hope and tie, that many many happy returns of this blessed season may find you enjoying every comfort of life, is the fervent wish of

Yours
most respectfully
Michael Hackett

Cambridge Mass
May 4th 1903

My Dear Warden
I received your letter and my discharge and I want to thank you so much for the kindness you showed me when there and interest you have taken in me since.
And at any time or in any way I can return your kindness would be glad to to do so believe me
Sincerly yours
Geo W. Howard
417 Broadway

Many inmates who were illiterate upon entering prison learned to read and write and continued corresponding with the warden for many years after their release.

54

Secor Road was built to lessen the grade from the village to the railroad station. This stone wall on Secor Road remains as strong today as when it was built by inmates in 1897. The wall was built around the same time that contract labor was eliminated because of objections from labor unions. The builder of this project was William Purcell. The warden at the time was Omar V. Sage, and the village president of Sing Sing, which became Ossining in 1901, was William Brandreth.

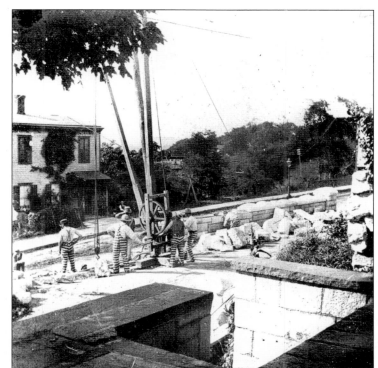

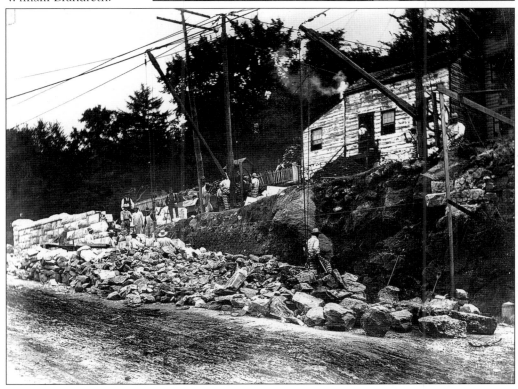

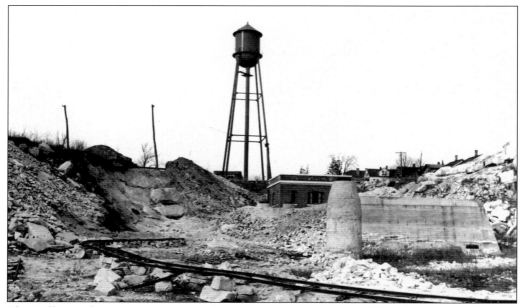

The trolley tracks seen in this photograph were used until the late 1800s to haul stone. The cars would roll down from the upper quarries to the river or railroad to deposit stone. Donkeys were used to pull the carts back up the hill to the quarries.

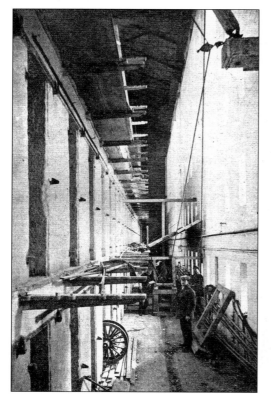

The stone left over from demolishing the old cellblock in 1918 was used as fill to extend the property at the waterfront. Because of rising inmate population, demolition was halted and prisoners remained in the old cellblock for two more decades.

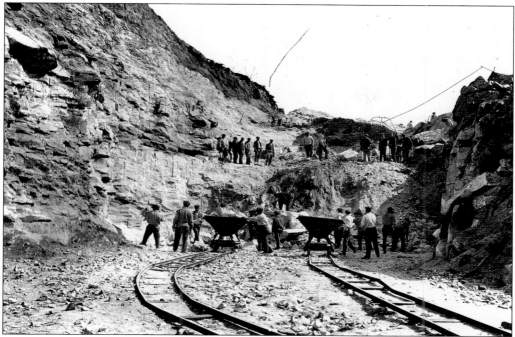

To accommodate the new prison site, the steep hillside had to be leveled. The difficult task of excavating and clearing the land for the new prison began in 1917.

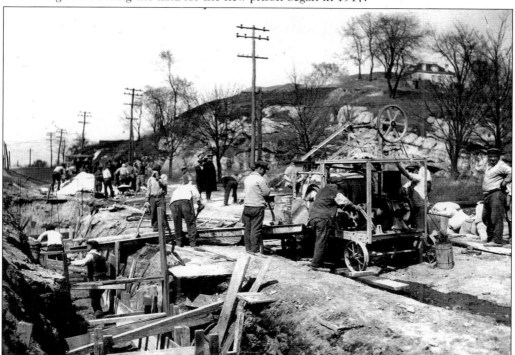

Construction for the new cellblocks began in 1917, and by 1922, the foundations for the new wall around the prison were complete.

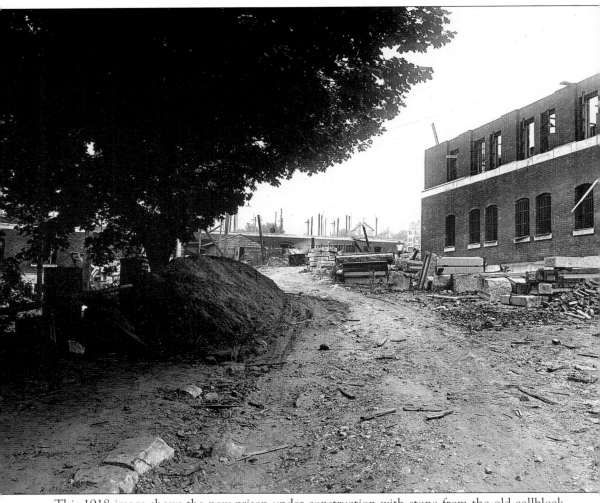

This 1918 image shows the new prison under construction with stone from the old cellblock being used in this building project. Houses on State Street can be seen in the background.

Three

WARDEN LEWIS LAWES AND PRISON REFORM

Born on September 13, 1883, in Elmira New York, Lewis Lawes is considered to be most progressive warden in penology. He started his prison career after military service, having grown up in the shadows of the New York State Reformatory, where his father worked as a guard. Lawes's first position was at Clinton Prison in March 1905.

After serving in various positions, Lawes took a leave of absence to attend the New York School of Social Work. He met and studied with Katherine B. Davis, who would become commissioner of corrections of the city of New York. In 1915, Davis installed Lawes as superintendent of the City Reformatory on Hart Island in New York City. The facility that housed the boys and young men was hardly adequate, as it shared Hart Island with a potter's field and a penitentiary for drug addicts and derelicts. The city agreed with Lawes's suggestion to relocate the reformatory off the island. Land was purchased in New Hampton in Orange County for the construction of a new reformatory. The young prisoners assisted in all phases of building at New Hampton, as was the case in the building of Sing Sing Prison. When it was completed, the reformatory was operated much like a working farm.

In 1920, at the urging of Gov. Alfred E. Smith, Lawes accepted the wardenship of Sing Sing Prison. Until that time, the office of warden was a political appointment and was subject to change with each newly elected administration. Lawes accepted the office on the grounds that it was not a political job and he would run the prison his own way. As warden, Lawes oversaw the complete overhaul of Sing Sing's physical plant and the procedures by which it was run. While Lawes believed that prisoners should be rehabilitated as well as punished, he also believed reform and rehabilitation were the first priorities.

Lawes encouraged the use of sports as recreation and also as a way for the inmates to develop an appreciation of rules. He believed that while a prisoner was serving his term, he should not lose contact with the outside world so he would fit in with society upon his release. He arranged for famous people to visit and give speeches to the inmates. Among these celebrities were Jack Dempsey, Harry Houdini, and Babe Ruth. Many stars came to entertain, including Red Skelton, Jimmy Durante, George Raft, and Edward G. Robinson. Actor Paul Muni presented a

play called *Counselor at Law*, which was running on Broadway at the time. The prisoners presented an annual theatrical performance that was open to the public. Lawes's willingness to treat the prisoners fairly and to meet them halfway on issues gained the inmates' respect. He allowed them to landscape the prison grounds and plant expansive flower gardens—work the inmates eagerly enjoyed, as it gave them a sense of accomplishment.

By the mid-1920s, the prison had become overcrowded and was in need of major renovation and updating. In 1926, the state granted $2,775,000 for additional construction. By 1929, two new cellblocks with 1,366 cells, along with a mess hall and new chapel, were completed. A year later, a laundry, bathhouse, and barbershop were added, and the industrial plant and workshops were completely rebuilt. By 1936, a school building, hospital, and library with 15,000 books were installed. Warden Lawes, who used prisoners to provide most of the labor, supervised this massive rebuilding. Unlike previous prison construction projects, the prisoners were treated well and paid as much as 30¢ a day for their work, depending on the type of work being done.

With the completion of the New Prison on the Hill, the prison's combined total area increased from $14^1/2$ acres to $47^1/2$ acres. It was the most modern and innovative prison of its kind. By 1943, two years after Lawes retired, the last of the prisoners were removed from the old cellblock. The damp, cramped, and unsanitary cells were eliminated for larger, cleaner, and well-lit cells with plumbing and running water.

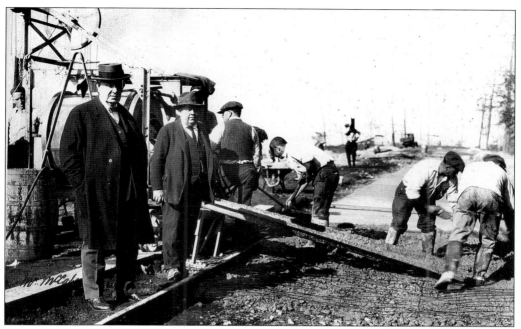

The years between 1920 and 1932 saw a building boom at Sing Sing. More than $8 million was spent on various projects. A prison gang is shown using a state-of-the-art cement mixer to pour a roadbed.

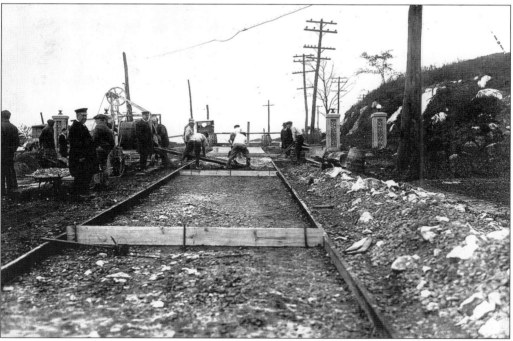

As topography of the prison changed, old dirt roads within the prison had to be upgraded. By 1922, solid concrete roads were constructed to handle the traffic of trucks and heavy equipment.

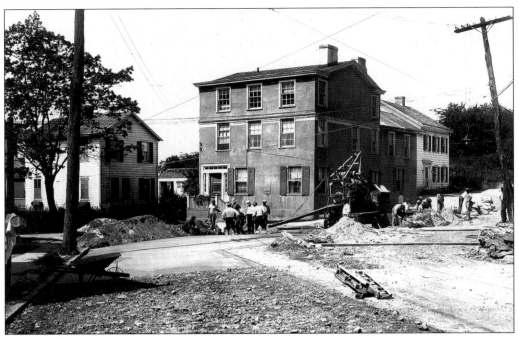

During the renovation and building of the new prison, village roads were also upgraded as shown in this 1924 photograph. Pipes were laid to connect the village water supply to the prison.

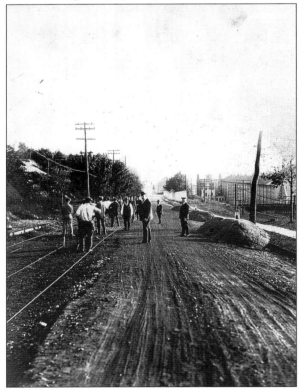

With construction of the new prison complex, new public roads adjacent to the prison were needed. Shown here is the construction of a new road approaching the prison from the north in 1923.

Inmate road crews—or "gangs," as they were called—were employed by the village of Ossining to repair and surface existing roads within the village. This *c.* 1920s photograph shows State Street heading toward Main Street. The present site of the new post office is on the right in this image.

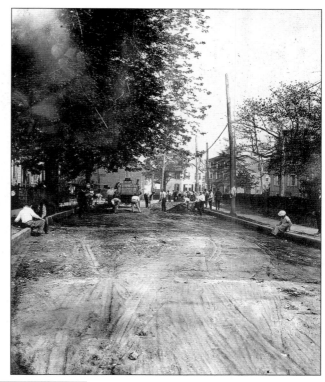

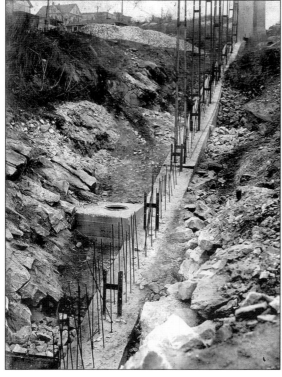

The foundation of the new prison wall will connect existing guard towers. Houses on State Street can be seen in this photograph taken in October 1925.

63

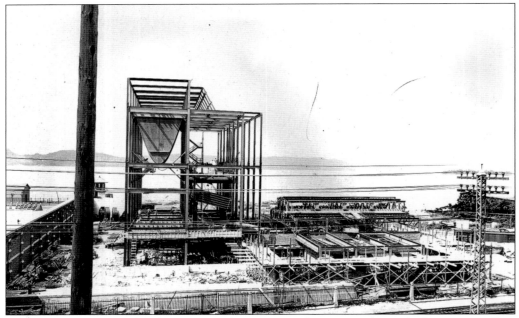

By 1936, construction of the new power plant was complete. Located outside the prison wall on prison property, the $1 million state-of-the-art building was built entirely by inmate labor.

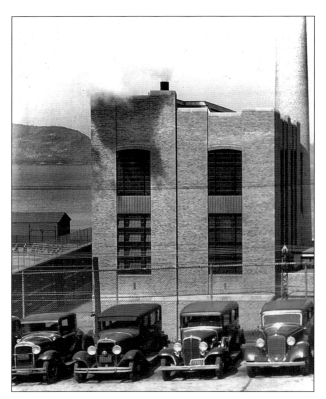

The powerhouse, shown in this 1930s photograph, used 10,000 tons of coal yearly to generate electricity. Six huge boilers supplied the power for the entire prison compound. Today, the lower level is used as a garage, and the upper levels are vacant.

The warden's office is decorated for Christmas in this 1925 photograph. Warden Lawes made sure every inmate was given a gift for Christmas. Such gifts might include shirts, socks, cigars, cigarettes, and calendars.

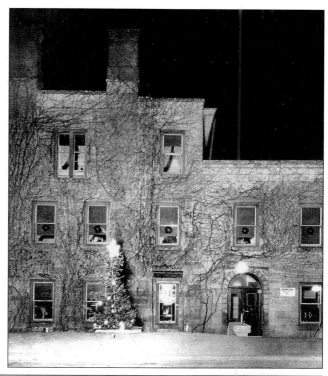

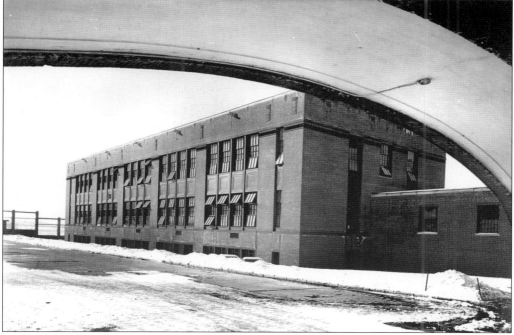

A new school was built in 1936, and inmates who were rated below a sixth-grade level were required to attend. Classes took precedence over all work assignments, and attendance was strictly enforced.

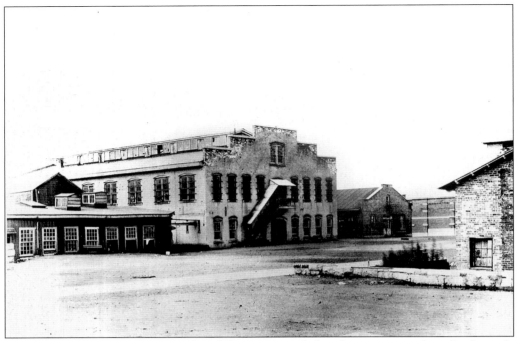

The general rule at Sing Sing was that if the prison needed it, the inmates made it. By the early 1930s, items produced in shops like these included mattresses, pillows, sheets, pants, underwear, bathrobes, shoes, gloves, slippers, and countless other items.

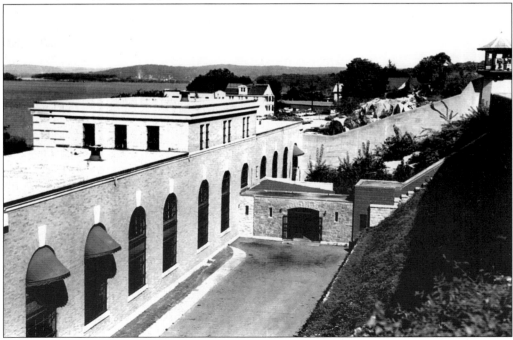

This image shows the rear entrance of the administration building c. the 1950s. The rock outcropping just beyond the inclining wall was the source of the stone used to build the old prison.

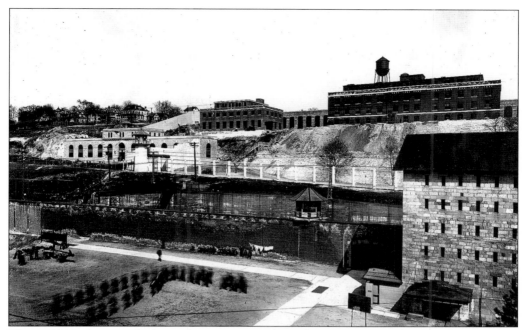

This *c.* 1929 photograph shows the new prison from the recreation yard. The administration building is on the left, the laundry is in the center, and the hospital is seen in front of the water tower. The old cellblock is to the right of the yard.

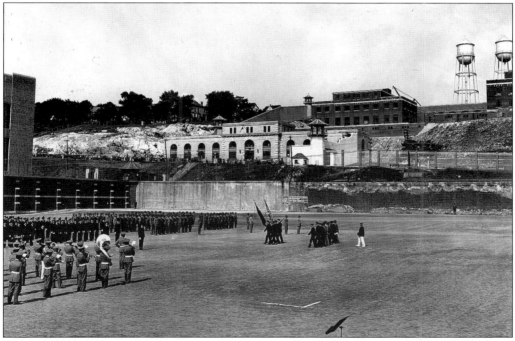

This photograph shows the swearing in of officers in 1939. The color guard enters as the band plays "The Star-Spangled Banner." Shown on the left in this picture are the prison officers with inmates on the right. In the background, a crowd gathers on the hillside to observe the occasion.

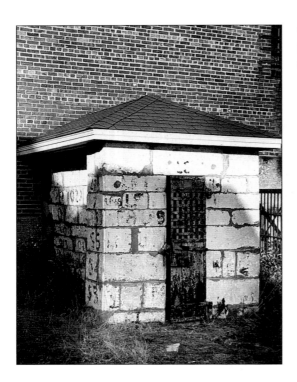

This replica of an original stone cell was built in 1972 behind the prison chapel and illustrates how small these cells were.

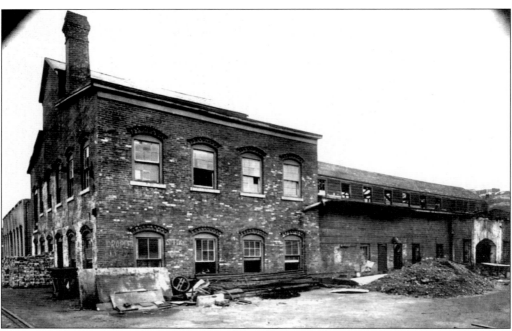

By the 1960s, most of the industrial shops and buildings in the lower yard near the river were torn down to make way for a proposed new state road. The plan was heavily opposed by local civic and environmental groups. Eventually, because of economic reasons, the project was canceled, and the prison retained the property.

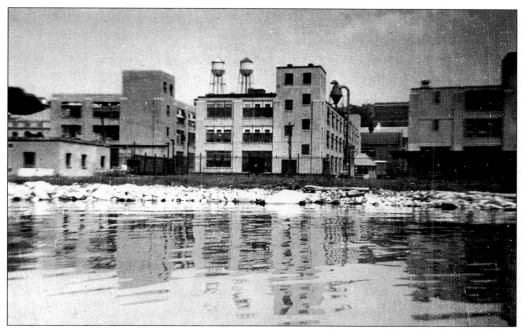

From 1943 to 1945, $54 million worth of prison-made goods were supplied to the armed forces. Items produced in the prison's industrial shops included boots, metal, clothes, tents, shoes, and bricks.

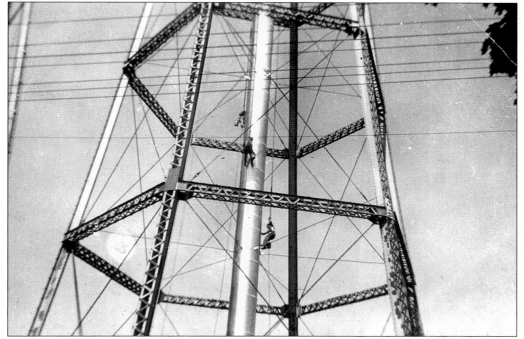

Painting one of the Sing Sing water towers in 1941 are, from left to right, "Shorty," Al, and Jay Soderberg. One of the inmates added a controversial picture to the side of the tank, and he was forced to climb the tower and remove it.

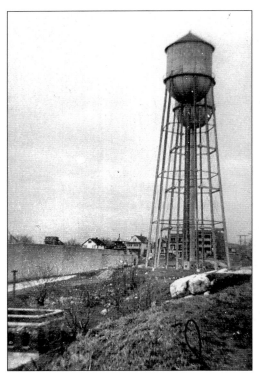

The water towers at Sing Sing were a landmark. The towers could be seen as far north as Bear Mountain and as far south as Irvington. In this 1940s photograph, South Street is in the background and State Street is out of frame to the right.

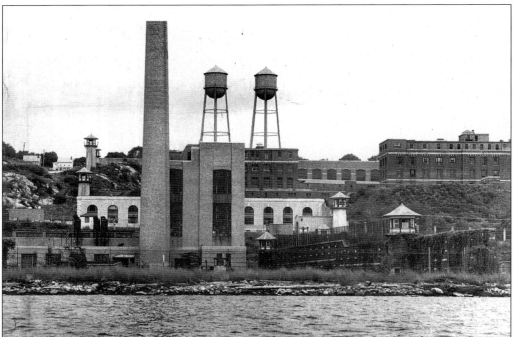

The water towers were located on top of the hill near State Street. Water was pumped up to the towers from the pipes that were tapped into the Croton aqueduct and fed through this system by gravity. The prison's powerhouse can be seen in the center of this photograph.

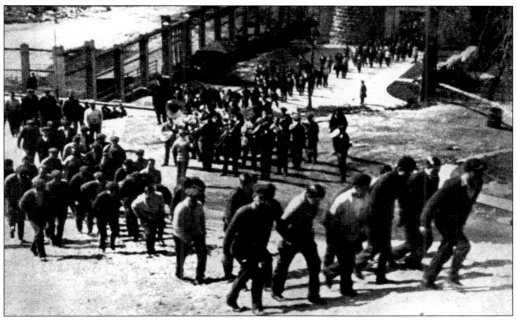

As the prisoners march to the mess hall, the prison band plays on in this 1928 photograph. As in the army, marching men can be handled more easily than an unorganized group.

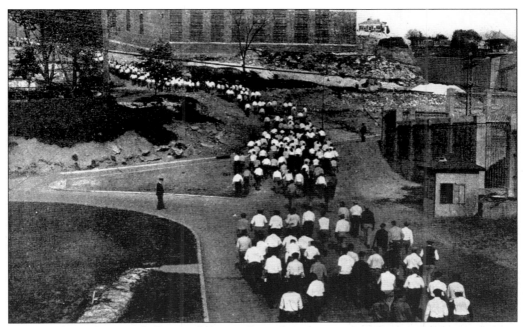

Inmates climb the steep hill toward their cells in the new prison. After supper, prisoners were permitted to use the grounds for recreation until darkness approached. Notice the guards keeping a watchful eye in this 1930s photograph.

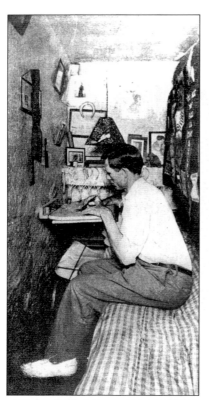

The cells in the original cellblock were equipped with a small cot, a writing platform, and a bucket used as portable plumbing. Due to overcrowding, inmates were housed here on a rotating basis until 1943.

By the 1920s, prison meals had become hardy and filling. The noontime meal included meat, vegetables, bread, and coffee. Supper, served at 4:00, was generally lighter but still wholesome.

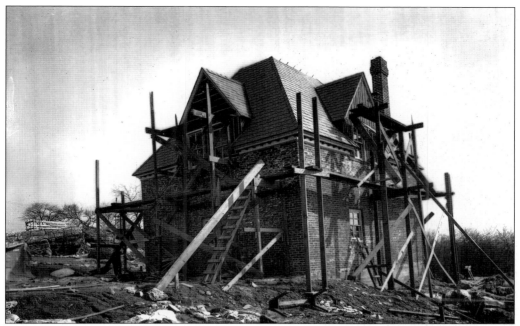

Construction of the new warden's residence outside the walls of the prison began in the early 1930s. The old home was located within the prison, and 2,000 convicts passed by this structure six times each day.

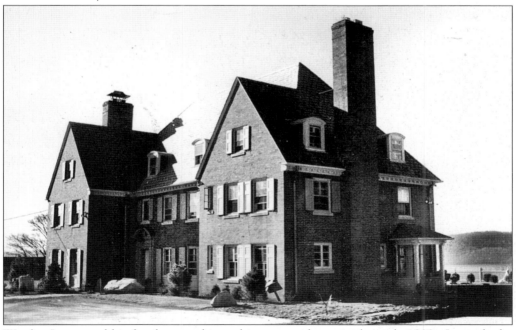

Warden Lawes and his family moved into this new residence in the early 1930s. Lawes had a staff of 12 inmates who worked at the house. The prisoners were used as waiters, gardeners, cooks, butlers, chauffeurs, and babysitters. The staff was increased to 18 when Warden Lawes entertained visitors. (Courtesy of J.M. Mejuto.)

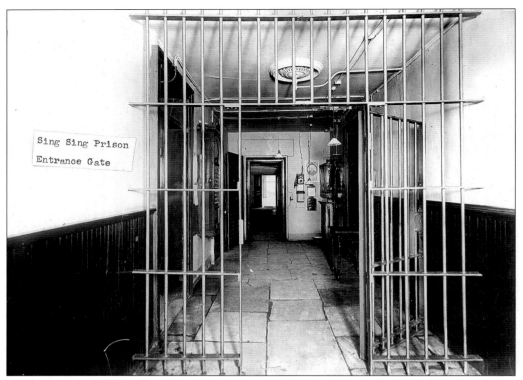

As the first view of Sing Sing that new inmates see, the entrance to the old cellblock is shown in this 1920 photograph. Notice the stone floor and the mahogany wainscoting that was popular at the time.

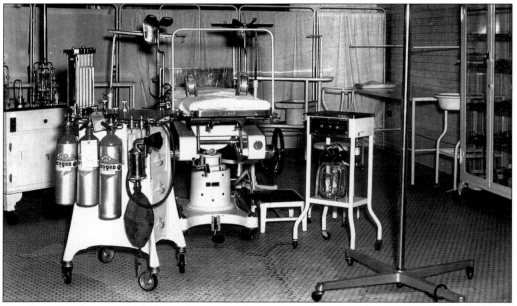

The Sing Sing hospital had a complete surgical team on premises, with as many as 713 operations being performed in 1929. Use of the prison's operating room was discontinued in the 1970s.

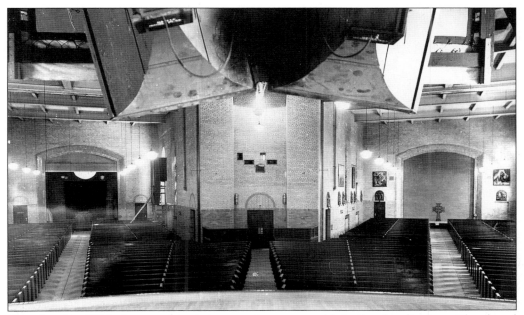

Completed in 1929, the new chapel also served as an assembly hall and auditorium. The chapel accommodated Protestants on the left and Catholics on the right and had stained-glass windows that were made by an inmate in 1943. The projection booth, in the center, was used when the room was being employed as an auditorium.

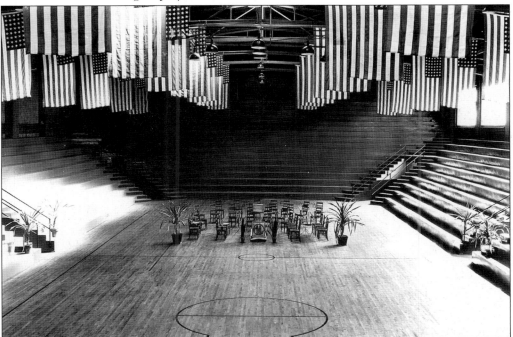

Built in 1934, the prison gymnasium was donated by Warner Brothers as a way of thanking Sing Sing for allowing films to be shot on location there. The facility was on par with any collegiate gym of the time.

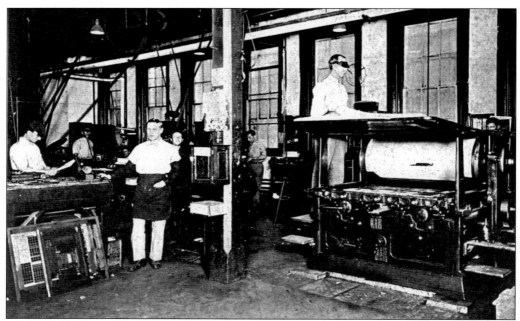

Former Ossining mayor Jesse Collyer Jr. was head of the Sing Sing print shop in the 1940s. The print shop provided printing of official department of corrections publications.

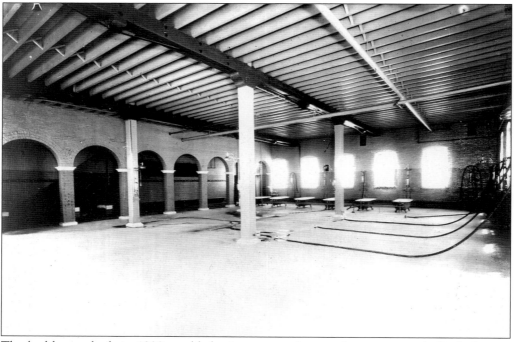

The bathhouse, built in 1930, enabled prisoners to take one shower per week. Each shop or gang was assigned a specific day to use the facility, and inmates were allowed to shower daily during their recreation period.

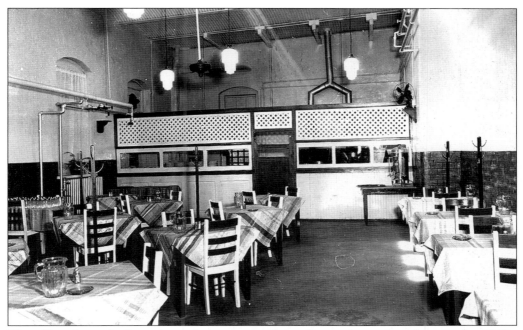

The officers' mess hall was located next to the duty office and was phased out in the 1960s. Guards and keepers ate meals prepared by inmates, and meals were also brought to guards on duty in the towers. The mess hall served meals on a staggered schedule throughout the day.

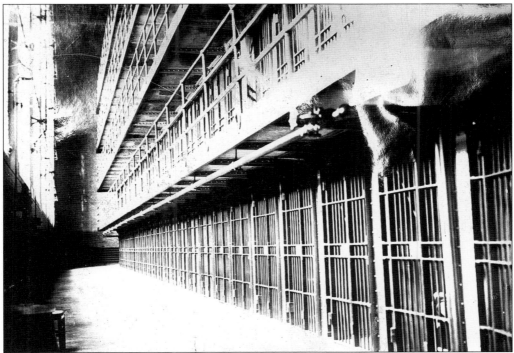

The new prison consisted of three cellblocks—A, B, and building No. 5. The new cellblocks were designed with five recessed tiers, as shown in this 1929 photograph.

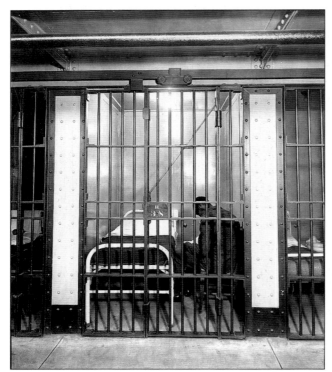

The cellblocks in the new prison were completed in 1929. These new cells were brighter and more spacious than the cells in the old prison. Each of the new cells was equipped with a toilet and a sink with running water.

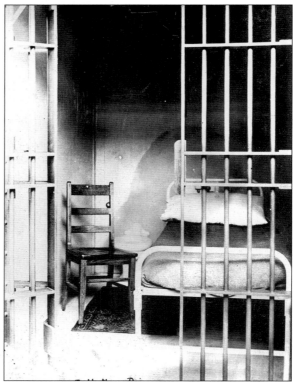

Each cell was furnished with a large cot, a chair, and a writing desk.

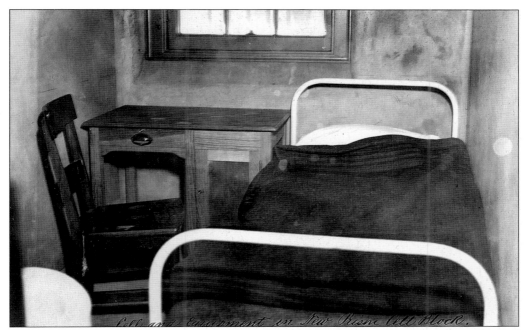

Cell and Equipment in New Prison Cell Block.

By the 1930s, prisoners were permitted to listen to the radio in their cells. The inmates favored wholesome shows that promoted family values. The radio broadcast started around 6:30 p.m. and was controlled by the warden.

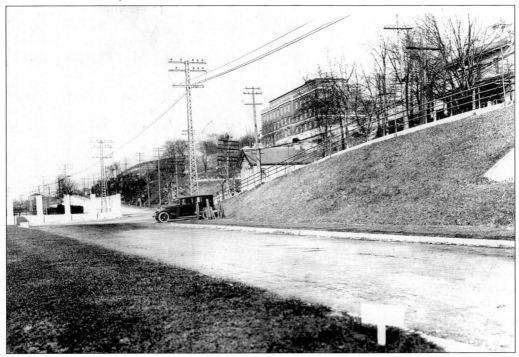

Hudson Street is shown in 1925 as it approaches the south wall of Sing Sing. This is now the location of the delivery entrance to the prison.

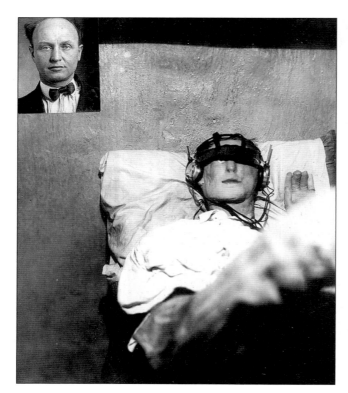

This dummy was discovered in cell 149 during the 6:00 p.m. head count on August 18, 1926. It bears a great likeness to inmate George Petersen. After this incident, all inmates were required to stand at their cell door for the head count.

Sheridan Tuffs, seated at the right, was chief clerk of the Bertillion department. He was in charge of fingerprinting and photographing new arrivals from 1922 to 1929. Fingerprinting, as a means of identification, was introduced in 1902.

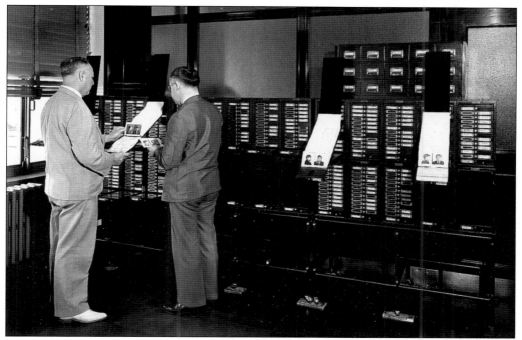

Sheridan Tuffs, on the left, views statewide identification photographs with an unidentified member of the state department of corrections c. 1943.

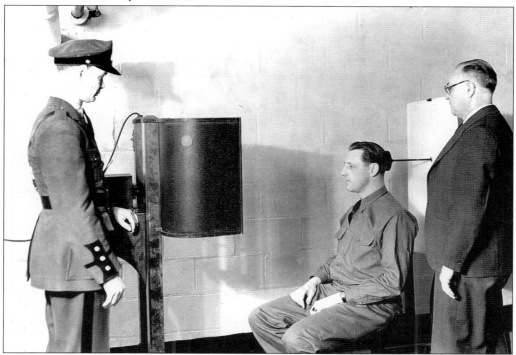

This c. 1949 photograph shows Sheridan Tuffs (right) conducting a training session for a state trooper in the process of prisoner identification.

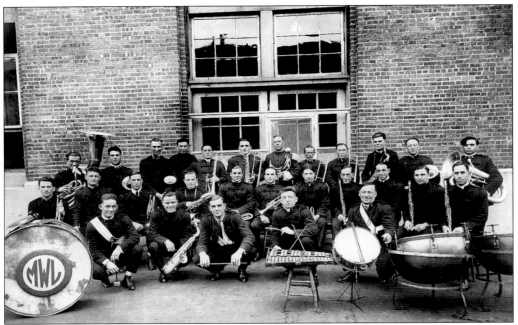

The Mutual Welfare League band is shown here *c.* 1927. Band members practiced on their own time during recreation period. They played the national anthem before all prison sporting events.

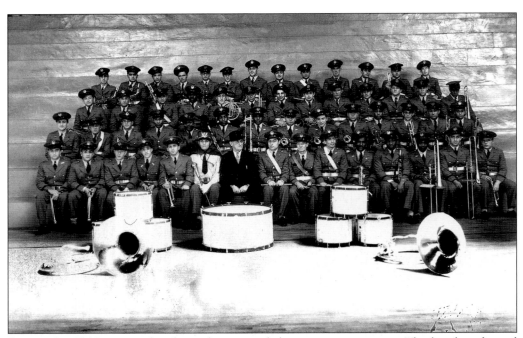

During the 1940s, prison band members owned their own instruments. The band performed concerts and played at special occasions at the prison. Upon their release, many former band members went on to become professional musicians, and several even played with major recording stars of that era.

Shown here is a scorecard from the opening day of the 1924 baseball season at Sing Sing. With a schedule that included traditional doubleheaders, the Mutual Welfare League teams played on Saturdays and Sundays from April through September.

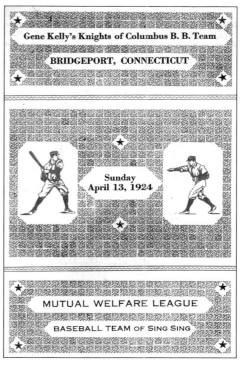

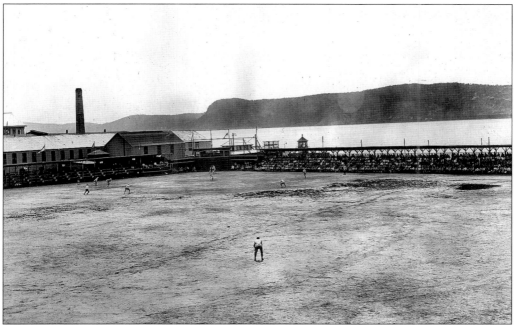

Sing Sing had a baseball league within its walls, and each shop fielded a team that played intramural games. Lawes Field, shown here in 1923, was where the games were played, with inmates seated in secured bleachers on the right. Visitors at the games sat on the opposite side from the prisoner bleachers.

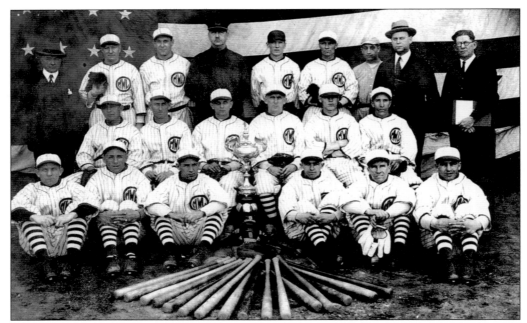

Baseball was in its heyday throughout the 1920s. The Mutual Welfare League sponsored a team of all-stars that played outside teams. The talent level of the players on this team was said to be equivalent to that of a good minor-league team. Several inmates went on to play in the minor leagues after their term was served. Warden Lawes, standing second from the right, is seen here with the first-place baseball team, the Black Sheep.

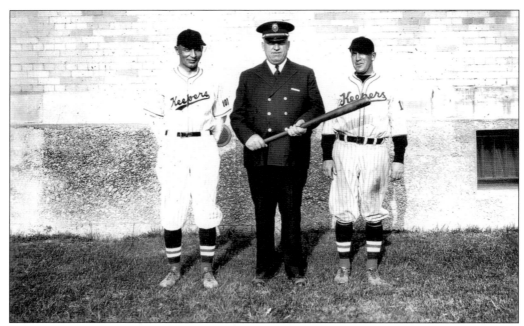

The prison keepers fielded a baseball team after the 1920s but did not play against the prisoners' team. Unlike the inmate team, the keepers included away games on their schedule.

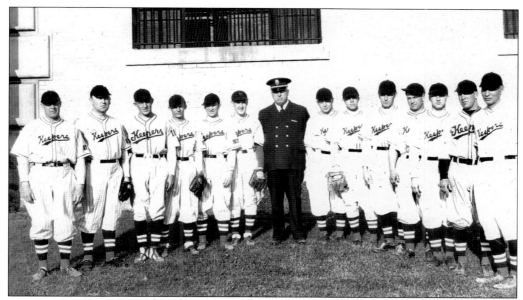

The Sing Sing keepers' baseball team was undefeated in 1935. The team members are, from left to right, Thomas Wilson, William McElroy, Charles Dolittle, George Erickson, Arthur Downey, Richard Riley, John J. Sheehy (principal keeper), John Tobin, Roy Taylor, James McGrane, Martial Yerry, John Tanzi, George Fuller (manager), and Thomas Pyrzgoad.

From c. 1917 to the 1930s, the Mutual Welfare League sponsored the annual athletic field day. Winners of sporting events won prizes donated from various outside sources. After a baseball doubleheader, the winners were treated to a fine dinner.

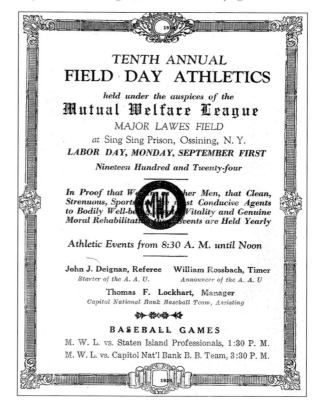

TENTH ANNUAL
FIELD DAY ATHLETICS
held under the auspices of the
Mutual Welfare League
MAJOR LAWES FIELD
at Sing Sing Prison, Ossining, N. Y.
LABOR DAY, MONDAY, SEPTEMBER FIRST
Nineteen Hundred and Twenty-four

In Proof that W........her Men, that Clean, Strenuous, Sports......st Conducive Agents to Bodily Well-be........Vitality and Genuine Moral Rehabilitati..........vents are Held Yearly

Athletic Events from 8:30 A. M. until Noon

John J. Deignan, Referee　　William Rossbach, Timer
Starter of the A. A. U.　　　　*Announcer of the A. A. U*

Thomas F. Lockhart, Manager
Capitol National Bank Baseball Team, Assisting

BASEBALL GAMES
M. W. L. vs. Staten Island Professionals, 1:30 P. M.
M. W. L. vs. Capitol Nat'l Bank B. B. Team, 3:30 P. M.

85

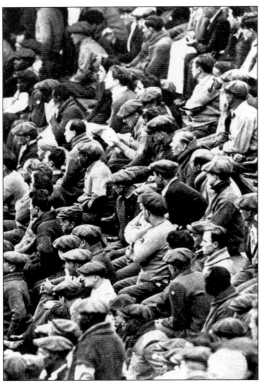

The sergeant at arms of the Mutual Welfare League and his deputies were responsible for orderly conduct at sporting events during the 1920s and 1930s. Security at these events was seldom an issue—the inmates attending these games considered admission a privilege.

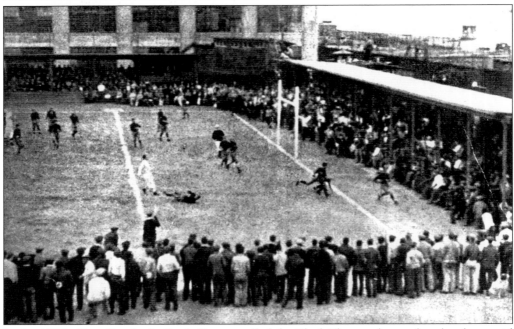

In the 1930s, Sing Sing had a football team called the Black Sheep, whose talent level was said to be comparable to a fair college team. During an average game, more than 2,000 men would line the field to watch the Black Sheep play.

MUTUAL WELFARE LEAGUE
OF SING SING

Book By
Mandell & Harbach
Music & Lyrics By
Harbach, Caesar
& Youmans

Do Good (MWL) Make Good

DECEMBER
10-11-12
13-14

Presents

Tenth Annual Show

"No, No, Nanette"
A Musical Comedy

Dear Friend:

 We are on the eve of another opportunity to present to the public, the TENTH ANNUAL SHOW of THE MUTUAL WELFARE LEAGUE of Sing Sing Prison.

 This year, the show of which you will note the title and dates on the heading of this letter, will be bigger, better and in every detail finer than any we have produced and in every way will represent the most impressive ever held by the League.

 The purpose of the Annual Show is to provide funds to enable the MUTUAL WELFARE LEAGUE, composed entirely of inmates of Sing Sing, to continue its work of constructive education behind walls.

 The actors are all prisoners who have learned their parts in the short period usually devoted to recreation after a days grind is over. It is a real sacrifice on their part with nothing to gain except the knowledge of having pleased the audience and furthering the welfare work of the League.

 We hope you are desirous of advertising in our Handsome SOUVENIR JOURNAL AND PROGRAM (a guaranteed circulation of over 10,000) or seeing this year's show. Fill out the inclosed order for advertising and tickets and you will be doing both yourself and the prisoners of Sing Sing a good turn. Indicate on TICKET ORDER the night you will attend. The show starts at 8:15 P. M. and train connections are assured.

Yours very gratefully,

MUTUAL WELFARE LEAGUE OF SING SING PRISON

By, _John M. Schonberger._

Chairman, Show Committee.

The Mutual Welfare League sponsored a theater group that staged a number of popular plays, such as *No, No, Nanette,* as shown on this 1928 invitation. David Belasco of the American Theater built a stage equipped with sound and lighting and presented it to the league as his Christmas gift to the prisoners.

Manned by heavily armed guards, the towers in this 1923 photograph were several of the 19 situated outside the prison walls. The entire wall was under constant surveillance, as guards could see from one tower to the next.

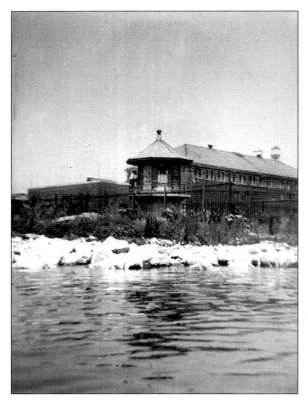

This is guard post No. 6, located at the southwest border of Sing Sing. The new "death house" is visible directly behind the guard tower in this 1940s photograph.

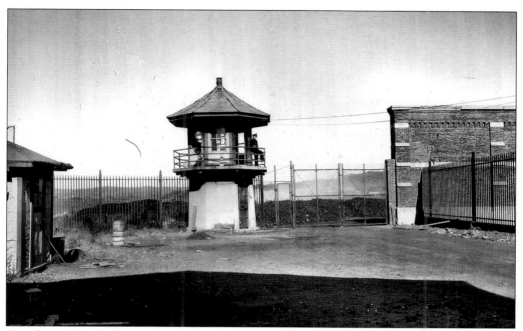

Guard post No. 10, shown here *c.* 1940, was relocated to the riverfront. It was moved again in the late 1970s, when the prison donated land to the town to build a water-sewer treatment plant.

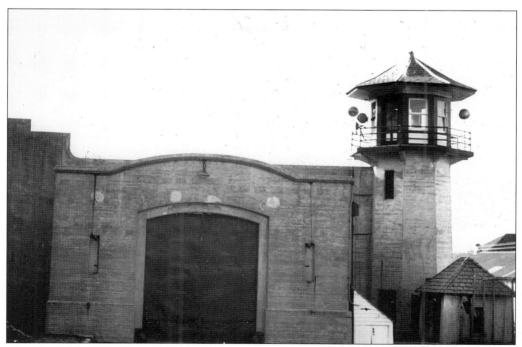

Guard post No. 12 is shown here from Hunter Street. At one time, this was a delivery entrance, but today a visitor's room is housed behind this wall. The present-day administration is directly to the left of the gate.

Before running water, inmates would provide drinking water to the guards. Each tower was equipped with a Thompson submachine gun and several high-power searchlights, depending on the location. By the early 1960s, each tower had a small desk and chair, a small sink, and a toilet.

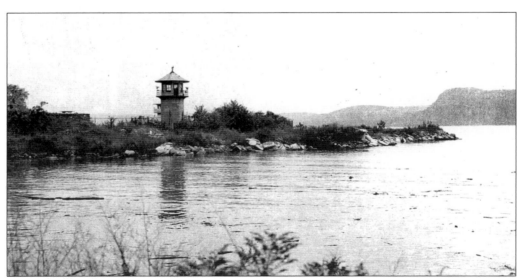

The area of land where guard post No. 12 stood c. 1940 was donated to the town of Ossining and is now the site of Louis Engel Park.

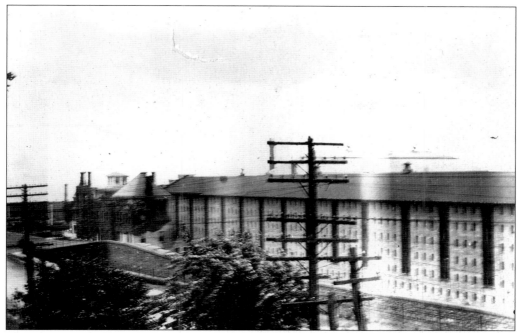

This photograph shows the tunnel where the train would stop to load and unload prisoners. The area where the prisoners would disembark was called a train lock, which was surrounded by four high walls to deter any escape attempts. Until the 1970s, the New York Central Railroad stopped inside Sing Sing for visitors and employees.

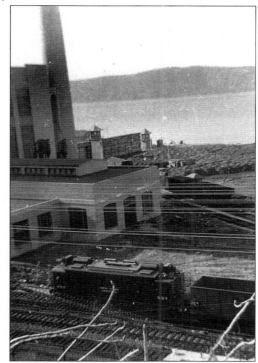

Until the late 1960s, the New York Central freight trains would divert from the main track and pull up to the platforms of the industrial shops. This sidetrack would enter through a gate and run along the river and back to the main track. Supplies were unloaded and products were loaded for state-owned destinations.

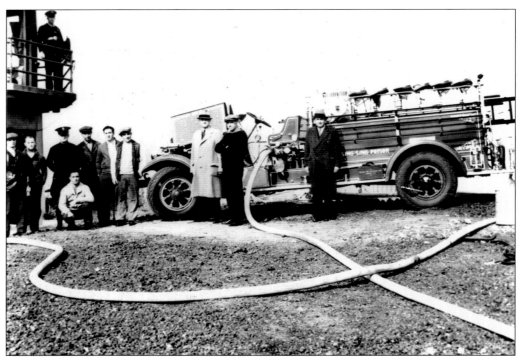

The prison fire department is shown *c.* 1920.

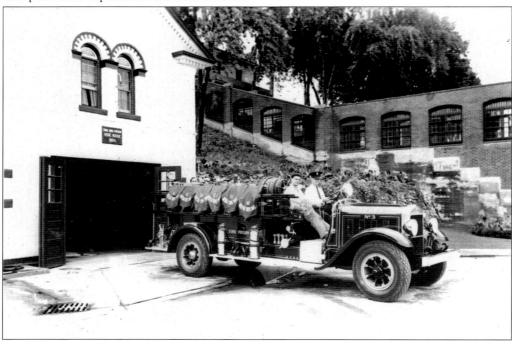

The prison firehouse, called the Sing Sing Prison Hose House, was built in 1894 and remained in service until 1971. The prison fire department worked in conjunction with the Ossining Fire Department.

Prison guard John Hartye (shown here) and Ossining police officer James Fagan were killed during an escape attempt in April 1941. Escape attempts were relatively infrequent, with the average being fewer than three in 1941.

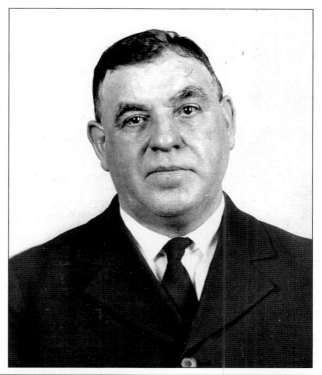

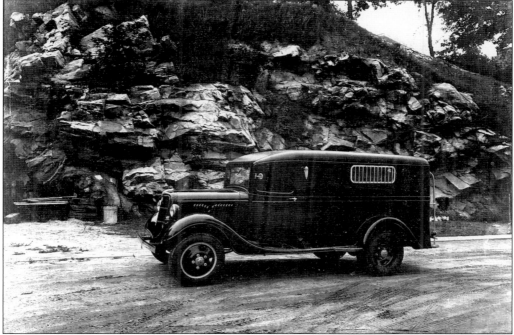

Inmates were transported to and from other prisons in this 1930s-style paddy wagon. Paddy wagons were used until the 1950s, after which they were replaced by customized vans and buses that adhered to department of corrections security codes.

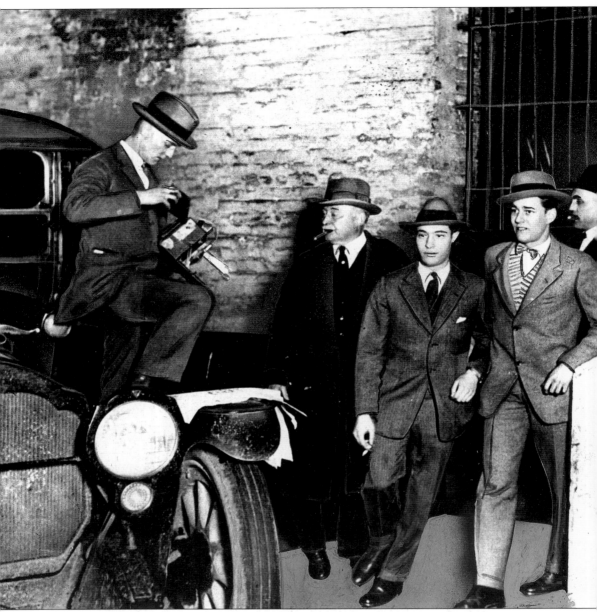

Nathan Leopold (in the center) shocked the nation when he murdered a young man just for "kicks" in 1924. Leopold was given a sentence of 99 years in Sing Sing. He was eventually paroled and lived the rest of his life in Puerto Rico.

Warden Lewis E. Lawes is on the left with Principal Keeper John J. Sheehy. Under Warden Lawes, Sing Sing would become the most progressive prison of its kind. Lawes oversaw the overhaul of the prison complex, and from 1926 to 1930, many new structures were built, including two cellblocks, a chapel, administration buildings, a library, and a mess hall.

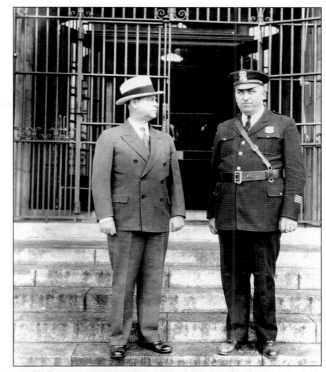

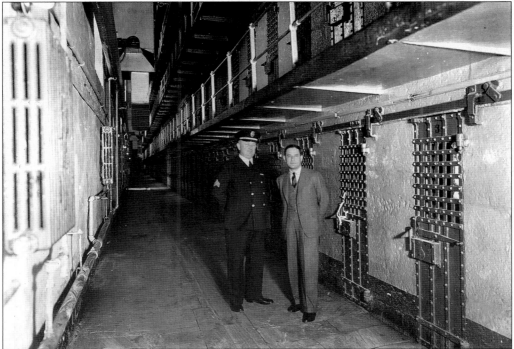

Shown here is Warden Lawes with Principal Keeper James Connaughton at the time Lawes took office in 1920. Connaughton served as acting warden briefly in 1913.

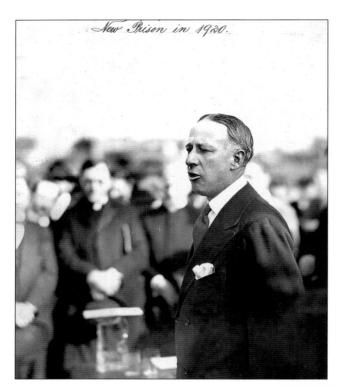

New Prison in 1920.

Gov. Alfred E. Smith is shown here laying the foundation stone of the new prison in 1920. It was Smith who encouraged Lawes to assume the wardenship of Sing Sing in 1919.

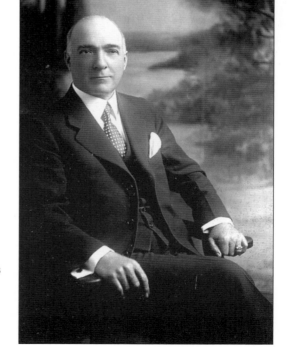

In March 1920, James L. Long, superintendent of prisons, allowed prisoners with discipline problems to be transferred from Clinton Prison to Sing Sing. These prisoners were put to work in the industrial shops and became model prisoners under Warden Lawes's reform policy.

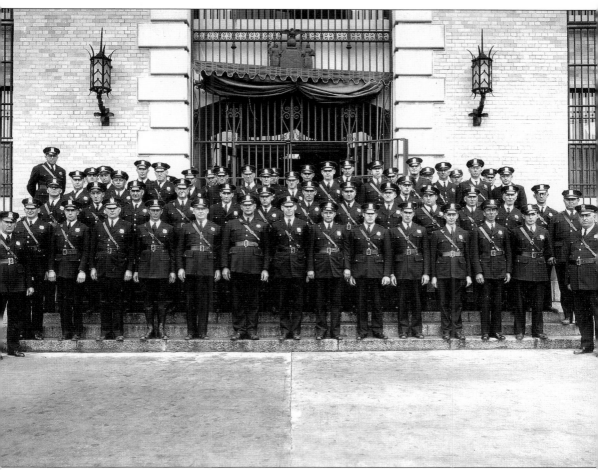

This sharply dressed group of guards shown *c.* 1935 is wearing Sam Brown, leather belts across their chests. The leggings that some wore, called "Putties," were worn mostly by mounted personnel and were being phased out at the time. Principal Keeper Sheehy is shown standing at the far right in this photograph.

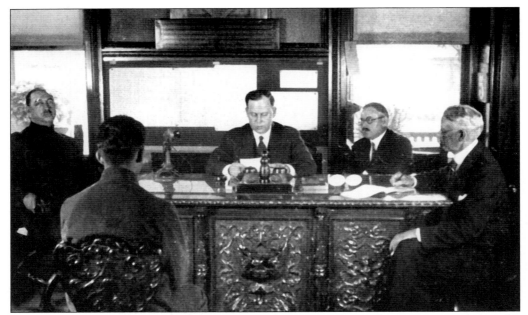

The parole board of Sing Sing Prison is shown here in 1925. Warden Lawes is seated in the center, with Dr. Amos Squire to his left. The prisoner is seated facing the board. Lawes believed an inmate should learn a trade while in prison, and as prison policy, a prisoner must have a job waiting for him before being paroled.

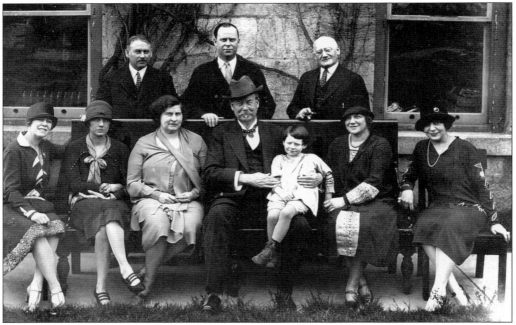

Sir Thomas Lipton, the tea baron, is shown seated in the center of this 1928 photograph. Lipton was a frequent guest of Warden Lawes, and he supported prison reform and donated money and merchandise to the Mutual Welfare League. Warden Lawes's youngest daughter, Cherie, is seen sitting on Lipton's lap in this photograph.

As principal keeper at Sing Sing, John J. Sheehy was the highest-ranking uniformed officer and was second in command to Warden Lawes. Sheehy held this position until he retired from Sing Sing in 1941.

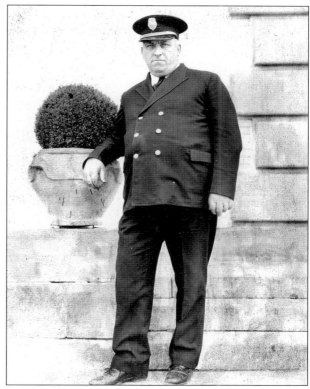

Warden Robert J. Kirby and his wife, Gladys, are shown at the warden's residence on May 9, 1943. Kirby continued the trend toward prison reform while in office from 1941 until 1944.

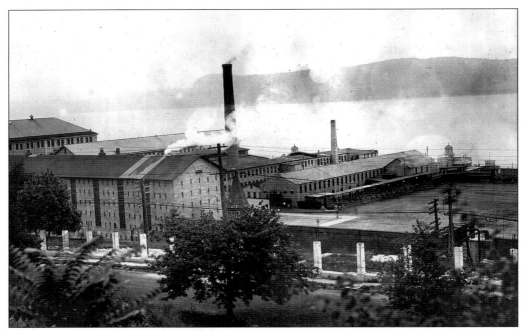

This view of the old prison and ball field was taken in 1923. Notice how the trees and vegetation have matured from earlier pictures. Electric and telephone lines can be seen stretching across the center of this photograph.

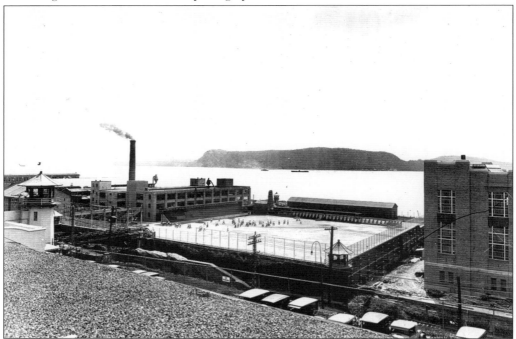

This west-facing view shows inmates using the recreation yard c. 1920. Prisoners were allowed 30 minutes for recreation after breakfast and lunch. After supper during summer months, inmates were permitted three hours of outdoor recreation time.

This photograph shows the entire prison complex. The old prison, closer to the waterfront, and the new prison, on the hill, are separated from one another by the railroad tracks. By 1936, the total area of the prison had tripled with the addition of the new prison.

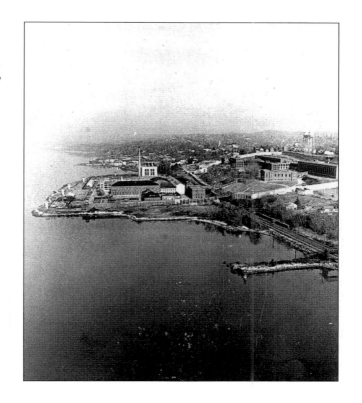

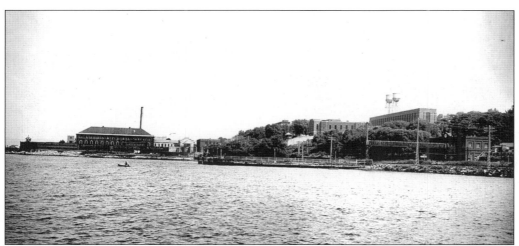

In 1928, a motorboat was purchased to patrol the waterfront area in front of the prison. Some years before, a prisoner swam away unnoticed by attaching breathing tubes to a flock of decoy ducks.

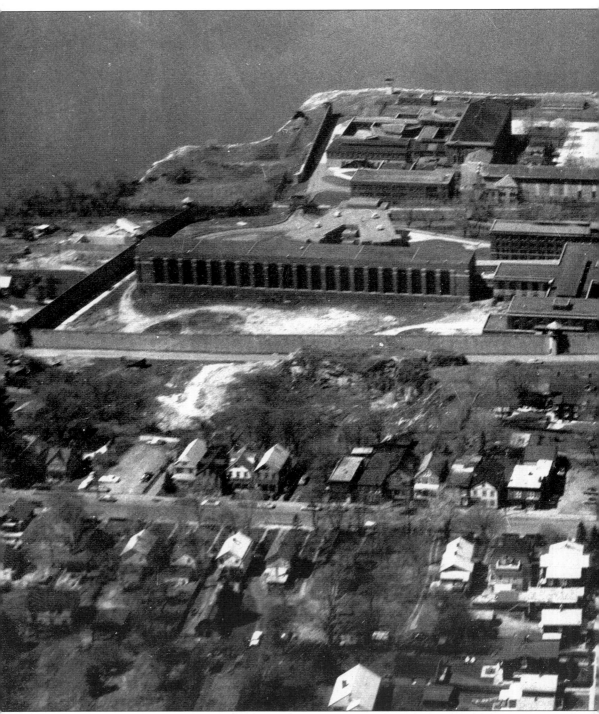

Shown here in this west-facing photograph is a view of the new and old prison c. the 1940s. Cellblocks A and B are the long brick buildings with the chapel between them, and on the right are the ever-present water towers. Behind cellblocks A and B is the old cellblock, and beyond

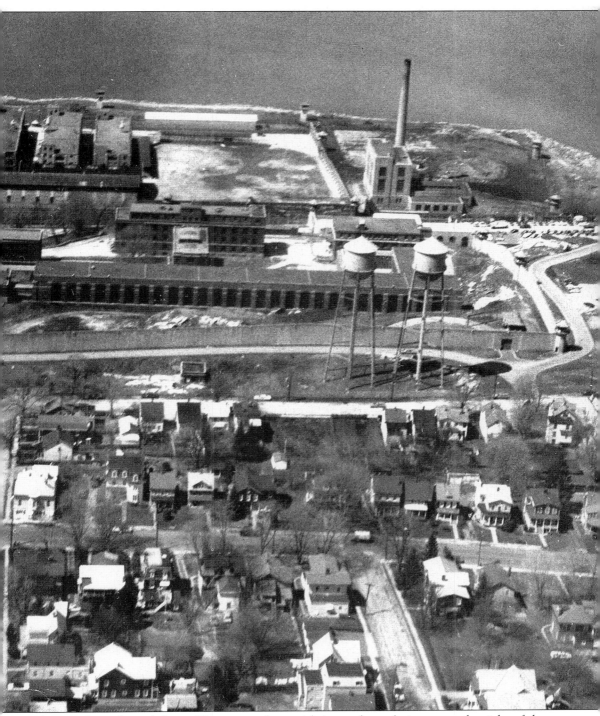

that are the industrial shops. The power plant, with its smokestack, is seen to the right of the ball field.

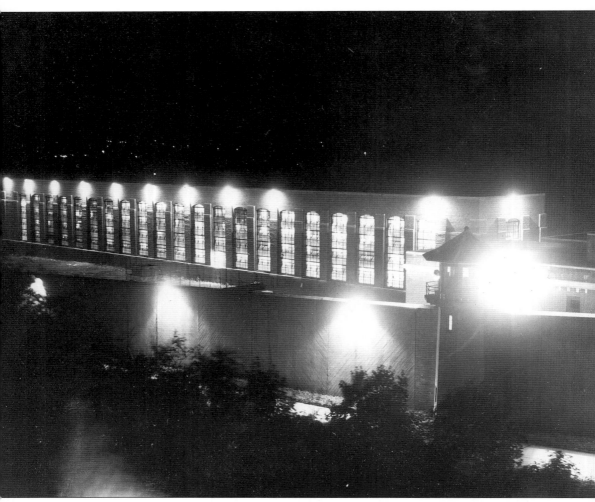

This west-facing photograph taken from State Street shows cellblock B and guard tower No. 16. The cellblocks were well lit by the 1940s, a notable difference from the nights of total darkness during the early years of Sing Sing.

Four

THE ROSE MAN

Charles E. Chapin was a legendary figure of Sing Sing who helped change the drab prison landscape to one of beauty and green fertility. Chapin, a confessed murderer, met Lawes in December 1919 at the prison hospital, where Chapin was a patient and Lawes was touring the prison before becoming its warden. At the time of his murder conviction, Chapin was 60-year-old editor of a New York City newspaper.

When Lawes returned as warden in January 1920, he found Chapin still in the hospital gravely ill and not expected to live. It was Lawes's intuitive nature that made him believe Chapin could be rallied from his bed with an offer of a meaningful job. He offered Chapin the job of editor for the prison newspaper, which he eagerly accepted and was out of bed inside a week. Chapin built the newspaper to one of the best prison newspapers in the country. The paper was eventually discontinued because of administrative circumstances.

Before long, Chapin asked the warden to be assigned to take care of the lawn. A lawnmower, sickle, hose, and grass seed were purchased. Chapin felt better as the summer progressed and the lawn thrived. As time passed, Chapin requested funds to build a small flower garden in the prison yard. Lawes surveyed the bleak, desolate area and approved. "Put some life into the yard, we'll have trees and flowers, a real garden," said Lawes. "That's fine warden, I'll grow roses in that sand pit," said Chapin. From that time on, Charles Chapin was known as the Rose Man.

First the yard had to be cleared of refuse and topsoil had to be trucked in. By this time, the Rose Man had a gang of 30 men working for him. He and his gang worked hard to have the ground ready for spring planting. This project seemed to give him a new lease on life as he worked from dawn to sunset.

When it came time to order plants in the spring, there was not much money left in the budget for this purpose, and because of this, the supply was a bit meager. The plants were shipped from a nursery in a nearby town. The gardener followed them up with a visit to Sing Sing to see how they were being used. The gentleman met Chapin and gave him some practical suggestions. Soon, truckloads of plants were sent to Chapin from the gardener.

Chapin studied volumes of Luther Burbank's books and became a knowledgeable

horticulturist. The Rose Man turned the yard and surrounding areas into a parklike setting. When the flowers were in bloom, Chapin would personally deliver them daily to warden Lawes's office and the prison hospital.

By 1926, birds in great numbers started to roost in the treetops and rosebushes. Chapin envisioned a huge birdhouse among the gardens of Sing Sing. With donations from his friends on the outside and help from some of the inmates, in three years the birdhouse was completed. Now Chapin had a new passion, but his true love was still his gardens.

For 10 years, Chapin had turned the arid landscape to a mass of color, life, and beauty, but in the summer of 1930, renovations at the prison resulted in the destruction of most of the gardens. Chapin died of bronchial pneumonia on December 12, 1930, but after his death, the gardens were completely restored to their original beauty.

RECEIVING BLOTTER
SING SING PRISON

Number 69690

Sentenced *Jany. 14, 1919*

Received *Jany. 17 1919*

Grade *A*

Name *Charles E. Chapin*

Alias

Alias

Received from *N.Y.*

County *N.Y.*

Court *Supreme Part I* Judge *Weeks*

Plea *Con.* Term *20-0 to Life*

Crime *Con. Murder. 2d*

Term out by ~~Commutation, Expiration~~ or Parole. *January 16. 1934*

Where born *Westfield N.Y.*

Age *60* Occupation *Editor*

~~Single~~ ~~Married~~ Widower ~~Divorced~~

Height Weight Education *R&W.* Religion *Prot.*

Habits { ~~Moderate~~ / Temperate / ~~Intemperate~~ } Uses { ~~Drugs~~ / Tobacco } { ~~Idle~~ / or / Employed } { Father ~~Living~~ Dead / Mother ~~Living~~ Dead / No. of Children }

Residence when arrested *Cumberland Hotel Bway & 57 St. N.Y.C.*

Name of relative or friend *Marion A. Chapin, Sister*
Don C. Seitz. To N.Y. World N.Y.

Office Card ✓ Supt. Card P. K's. Card ✓ Number Book ✓

PREVIOUS COMMITMENTS

no

I hereby certify that the above is my criminal record. I further certify that the above statements were made by me voluntarily and without any promise or threats being made as an inducement to make the same.

Record taken by

Charles E Chapin

Sing Sing Prison 191 Witness

This "stat sheet" for incoming prisoners gave basic information about each individual. The Rose Man is not typical of one serving a life sentence for murder—he was 60 years old and his occupation was that of an editor.

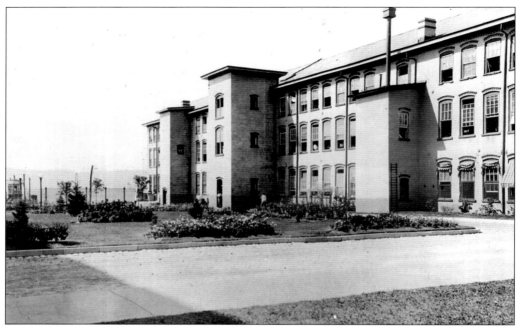

During Warden Lawes's era (1920–1941), the grounds were made beautiful with the planting of shrubbery, trees, and expansive flower gardens. All the work was done by inmates led by the Rose Man.

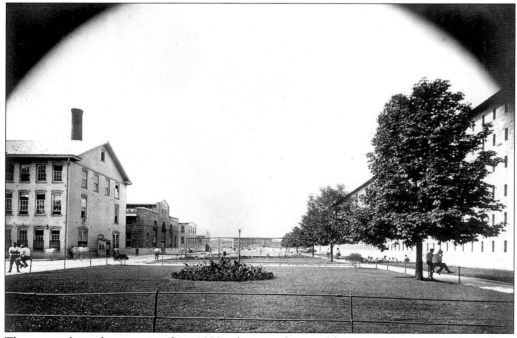

The central yard, seen in this 1922 photograph, would eventually be transformed to Connaughton Park—a series of flowerbeds and borders. Benches were added later, and men gathered around to spend their free time here.

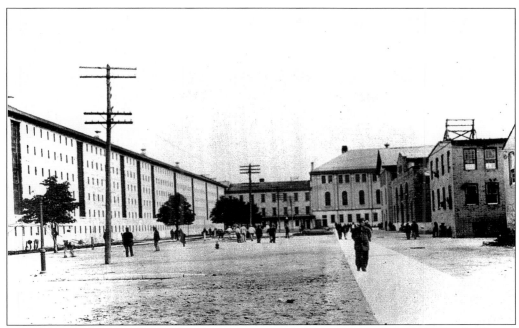

The photograph above shows what the prison grounds looked like before 1923. The landscape was barren and devoid of plant life. Under the guidance of Charles Chapin, Sing Sing's Rose Man, the area was transformed to a parklike setting.

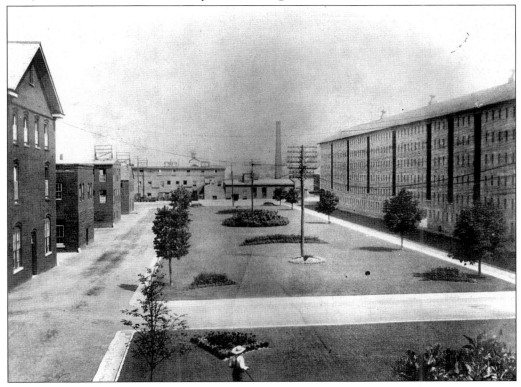

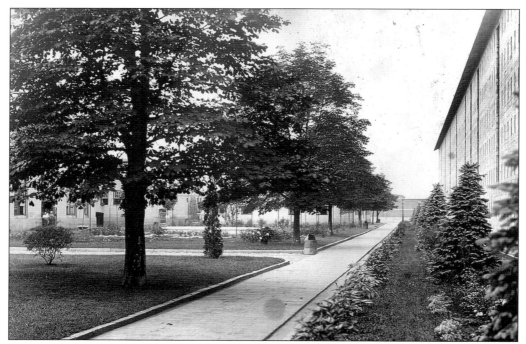

The area along the old cellblock wall was landscaped with shrubbery and perennial flowers. A slate walkway was installed and lined with decorative curbstones, and the area was always kept spotless and clean.

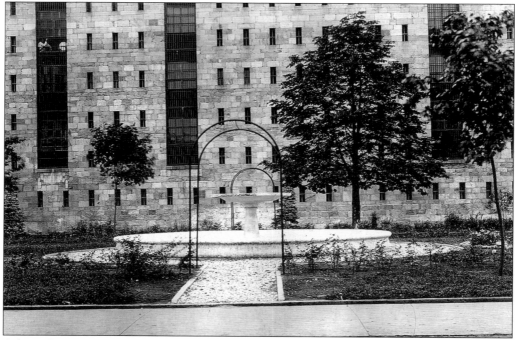

A huge fountain measuring 10 feet across was built in 1923. A crushed-stone walkway led to the fountain that was surrounded by lush turf, rose bushes, and flowering trees.

The Rose Man's greenhouses were located behind the old warden's residence toward the river. From seeds, Chapin grew many varieties of perennials, including dahlias, peonies, geraniums, and a dozen varieties of cannas.

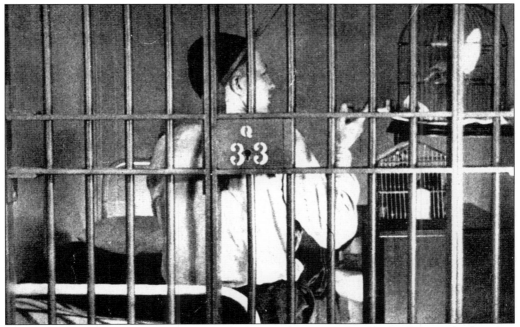

Warden Lawes allowed the prisoners to raise birds in their cells. The birds were displayed in the giant birdhouse located in the central yard. Lawes believed that reform was the first priority, treating the prisoners firmly but humanely. This image dates from the early 1930s.

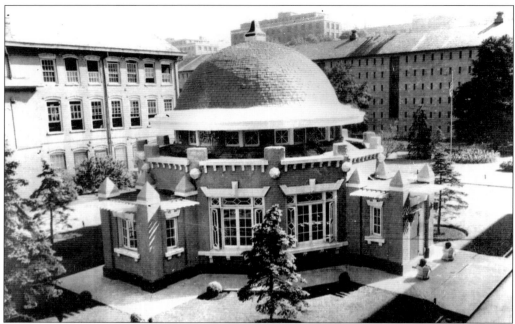

The Rose Man noticed birds roosting in the trees and was inspired to raise funds to build this huge birdhouse among the gardens. The birdhouse remained a fixture in the central yard until 1946, when it was demolished.

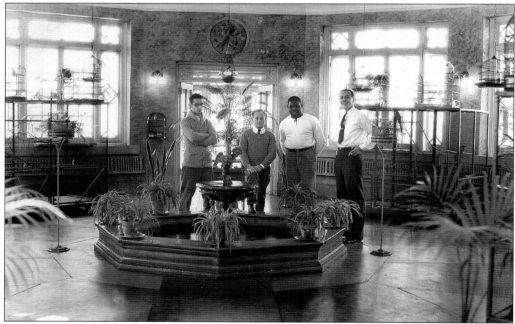

More than 150 exotic species of birds were kept in the birdhouse. Mrs. Lawes made sure the cockatoos, macaws, lovebirds, and parrots were well cared for. By the mid-1940s, groups of prisoners would congregate in the birdhouse for coffee during recreation time. Visitors are given a tour of the bird sanctuary in this 1929 photograph.

Five

THE ELECTRIC CHAIR

The electric chair has always been linked to Sing Sing. Thomas Edison invented the electric chair to show the dangers of alternating-current (AC) electricity as compared to the direct-current (DC) electricity that he developed. Edison and fellow inventor George Westinghouse were competing to dominate the electric power industry, with Westinghouse being a proponent of AC current. Edison's direct-current system was installed in several large cities, while Westinghouse had used the AC system with great success. It was Edison's plan to show the world how lethal AC current was in the home and thus capture some of Westinghouse's market.

At about the same time, New York State was in search of a humane method of execution. On June 4, 1888, Gov. Daniel B. Hill signed a bill authorizing the use of the electric chair. The jolt of electricity from the electric chair rendered the victim unconscious in less than a second, before any pain could be felt. The first execution took place on July 17, 1891, with Harris A. Smiler being the first person executed at Sing Sing. Four other prisoners were executed by similar means on the same day at Sing Sing.

Executions usually took place at 11:00 p.m. on Thursday nights. Twelve witnesses, along with two doctors, the prison chaplain, the executioner, seven guards, and the warden, were required to be present. The building that housed the electric chair was referred to as the death house. It was a prison within a prison. There were 24 cells, plus an additional three cells for women. It had its own hospital, kitchen, visiting room, and exercise yard. The section where the prisoners spent their last day was called the dance hall. This pre-execution chamber was connected by a corridor, which was called the last mile, to a room where the chair was located.

In 1928, the execution of Ruth Snyder caused a state of commotion and uproar. Snyder and her boyfriend, Judd Gray, were convicted in a triangle murder. The press portrayed Snyder as the victim in this crime of passion, and the public sympathized with her. On the night of the execution, thousands of people milled around the gates of Sing Sing. Special telegraph wires had been installed on the hills overlooking the prison to report the details of her final hours.

Francis "Two Gun" Crowley was 19 when he was executed in the electric chair in 1932. He arrived at Sing Sing as a murderer and vicious criminal. Crowley became the notorious two-gun

bandit when he murdered a police officer. While in the death house, he set his mattress on fire, fought with the guards, and destroyed his cell. Crowley was moved to a special cell that was isolated from all other prisoners on death row. About three days after his isolation, a starling flew into Crowley's cell. He fed the bird, and it kept coming back. The next day, Crowley agreed to behave if he could keep the bird. Crowley tamed the bird, and the bird apparently tamed Crowley. Crowley spent the remainder of his time in the death house drawing and sketching. He showed a talent for drawing, and his sketches were architectlike in quality.

Julius and Ethel Rosenberg were the first civilians to be found guilty of espionage in the United States. In 1953, the Rosenbergs were convicted of conspiring to transmit atomic secrets to the Soviet Union. In spite of court appeals and pleas for clemency, the execution still took place. This was the most highly publicized and controversial case of its time, and although the crime they committed was not murder, it carried the death penalty. There was public outcry over the fact that others implicated in this crime received much more lenient sentences. As the hour of retribution approached, crowds gathered and demonstrated at the gates of Sing Sing and in New York City, London, and Paris.

A total of 614 men and women died in the electric chair in Sing Sing, and since 1914, all executions in New York State were done there. The last execution at Sing Sing Prison occurred on August 15, 1963.

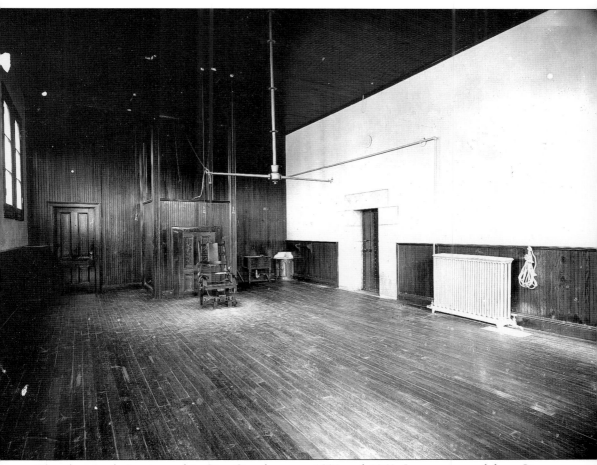

The electric chair was used in Sing Sing between 1891 and 1963. It was removed from Sing Sing and taken to Green Haven State Prison in 1971. Shown here is the execution chamber in the original death house.

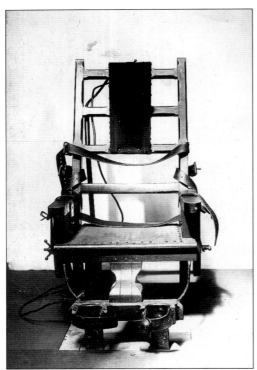

After 1914, the "death chair" was used only at Sing Sing. A total of 614 men and women died in the chair, the last being Eddie Lee Mays on August 15, 1963.

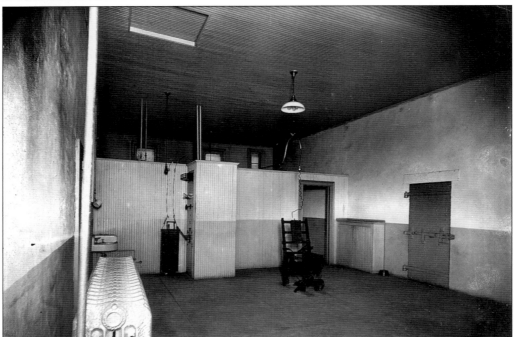

The execution chamber in the original death house was remodeled *c.* 1900. The chamber had been too close to the cells on death row, and inmates in those cells could hear the deadly hum of the electric motor, which led to desperate escape attempts.

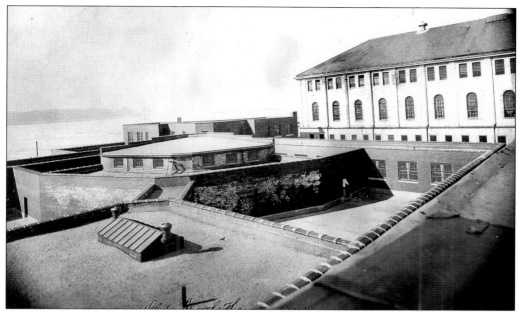

Used until 1922, the old death house was a small building made of stone. The prisoner's walk to the chair took them past the cells of those awaiting execution. There were two successful escape attempts from the old death house. One man was recaptured and executed after he killed a keeper. Two men drowned in the Hudson River while attempting to escape.

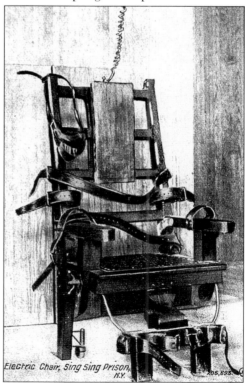

Electric Chair, Sing Sing Prison, N.Y.

This postcard was a popular selling item in the late 1890s. By the turn of the century, the electric chair had already become synonymous with Sing Sing.

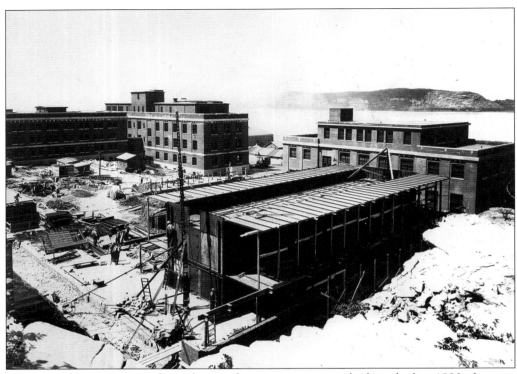

The "special housing unit," shown here under construction, was built in the late 1930s. Inmates who could not live in the general population because of disciplinary reasons were housed here.

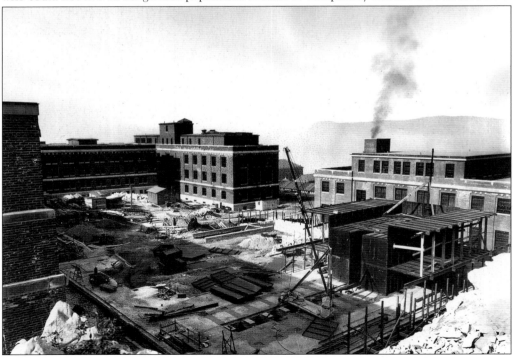

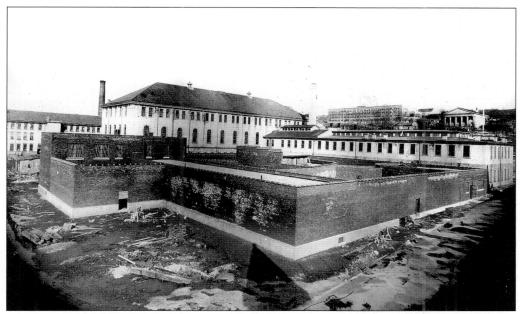

The nearly complete death house contains two wings with 12 cells each and two exercise yards. Inmates played basketball or handball with keepers or just sat in the shade and talked. In 1971, when the electric chair was removed, the death house was converted to a vocational shop.

The entrance to the new death house is seen in this 1926 photograph. The law stipulated that a condemned inmate must be held in solitary confinement while awaiting execution. Although it is possibly to converse with inmates in other cells, no prisoner could see another.

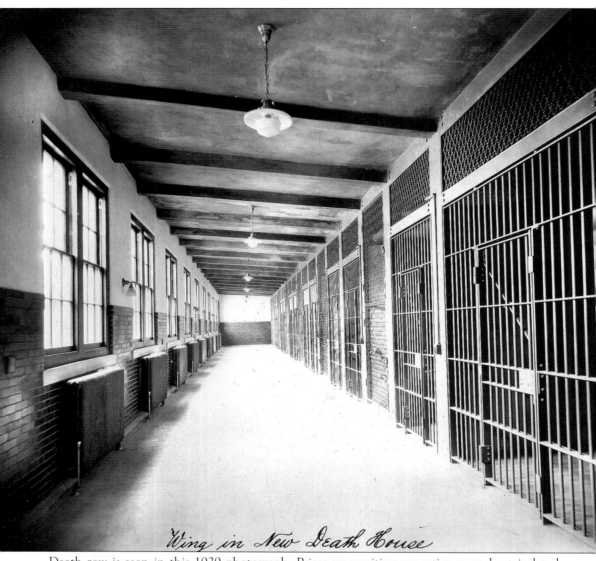

Wing in New Death House

Death row is seen in this 1929 photograph. Prisoners awaiting execution were kept isolated from the general prison population and under 24-hour surveillance to prevent suicide. Meals were passed through an opening in the steel doors, and smoking was permitted as long as the keeper lit the cigarette or cigar. For relaxation, inmates were allowed access to newspapers, magazines, and books from the prison library.

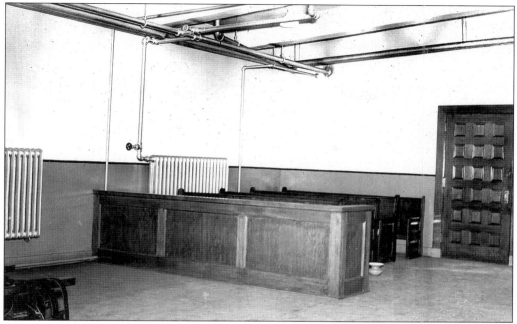

The 12 witnesses, warden, clergyman, and doctors were seated in this area of the new death house c. 1923. Although many volunteer to witness executions, witnesses are chosen from those who do so as a matter of civic duty and pride.

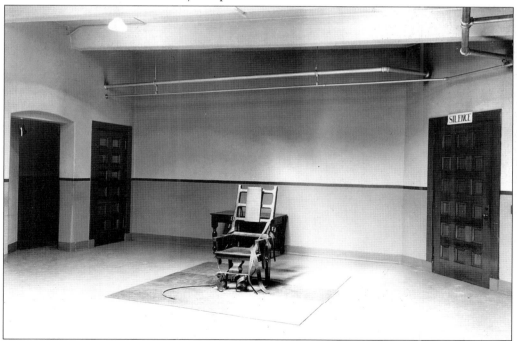

This photograph shows the electric chair in the new death house. The room had become as clean and sterile as a hospital operating room. The setting would remain this way until the removal of the electric chair in 1971.

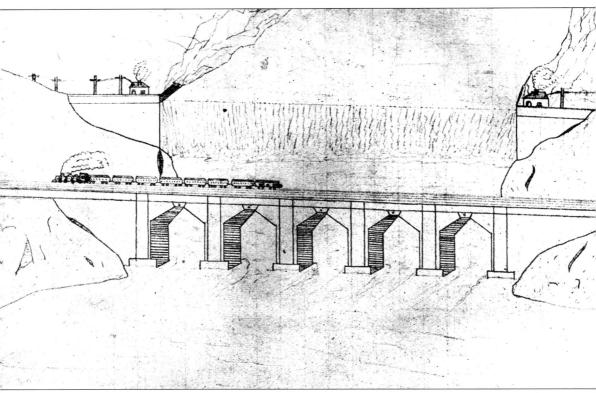

The notorious Francis "Two Gun" Crowley showed an aptitude for drawing and sketching while on death row. Crowley drew sketches of the Empire State Building, the George Washington Bridge, and the death house before his execution on January 21, 1932.

During her time on death row, numerous marriage proposals were offered to Ruth Snyder, who is shown here with her mother. The case was so sensationalized that a news reporter smuggled a hidden camera into the execution chamber. One million additional newspapers containing the picture of Snyder in the electric chair were sold on the day after her execution in 1928.

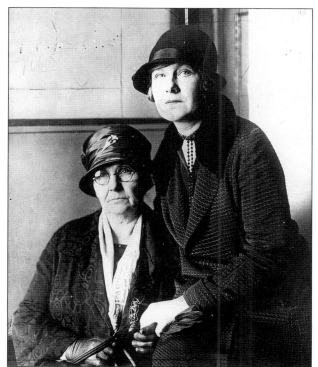

Police kept the crowd in order as the accused murderer entered the Queens County Courthouse to start her trial on April 19, 1927. Because of public outcry, the presiding judge almost reluctantly imposed the death sentence.

As crowds of Rosenberg protestors arrived, Ossining police set up roadblocks at the railroad station. Rumors of groups boarding Ossining-bound trains at Grand Central Station proved false. Ossining police and state troopers kept local demonstrators under control. Most of the demonstrations took place the day before the executions. On the day the Rosenbergs were executed, police were left to deal with only the throngs of newspapermen.

A Rosenberg sympathizer places flowers along the entrance to Sing Sing on June 19, 1953. Prison guards, state troopers, and village police were stationed on streets leading to the prison. Only reporters with proper credentials were permitted past checkpoints around the prison. At the time of the executions, radio and newspaper reporters set up at the Old Jug Tavern on Revolutionary Road. Radio communications were linked from the prison to the tavern and transmitted over the airways.

This image shows the old cellblock as it appears today with the stone around the iron door having been restored. Notice the tiny slitlike windows that had permitted little sunlight to enter this building 178 ago. (Courtesy of Burns Patterson.)

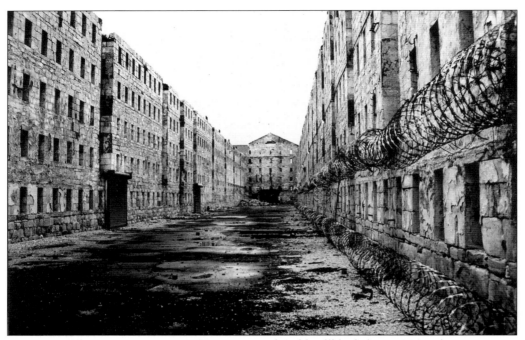

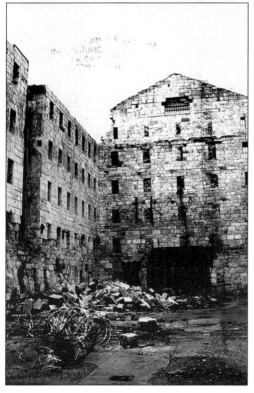

The old cellblock from 1825 is shown as it looks today. A fire burned the roof off in 1984, and only the outer walls remain. Until that time, the building was still used for industry and also contained a boxing ring. This structure has been listed on the National Register of Historic Places and can never be removed. There are plans to include this site on a walking tour of the prison. A museum is planned for inside the old power plant. (Courtesy of Burns Patterson.)

STATE OF NEW YORK
DEPARTMENT OF CORRECTIONAL SERVICES
SING SING CORRECTIONAL FACILITY
354 HUNTER STREET
OSSINING, NY. 10562-5442
914-941-0108
WARDENS / SUPERINTENDENTS
COMPILED BY CORRECTION OFFICER ARTHUR M. WOLPINSKY
FACILITY PHOTOGRAPHER & HISTORIAN
2/22/03

Name	Previous Occupation	Prison / Highlights	Date
ELAM LYNDS	WARDEN FROM AUBURN	MT. PLEASANT STATE PRISON	APRIL 23, 1825
ROBERT WILTSE		MPSP	OCTOBER 31, 1830
DAVID L. SEYMOUR		MPSP	APRIL 24, 1824
WILLIAM H. PECK		MPSP	MAY 10, 1843
HIRAM P. ROWELL	CLERK FROM THE PRISON	MPSP	SEPTEMBER 18, 1845
CHAUNCEY SMITH	BUISNESS MAN	MPSP	JANUARY 7, 1848
EDWARD L. POTTER	WARDEN FROM AUBURN	MPSP	JANUARY 10, 1849
ALFRED R. BOOTH	MERCHANT	MPSP (HUDSON RIVER RAILROAD)	JULY 1, 1849
MUNSON J. LOCKWOOD	PROFESSIONAL POLITICIAN	SING SING	NOVEMBER 20, 1850
C. A. BATTERMAN	POLITICAL DISTRIC LEADER		JANUARY 1, 1855
WILLIAM BEARDSLEY	FACTORY SUPERINTENDENT		MAY 10, 1856
GAYLORD B. HUBBELL	MERCHANT FROM SING SING VILLAGE		MAY 1, 1862
THOMAS E. SUTTON	TYPESETTER FROM MARRISANIA		JANUARY 1, 1864
STEPHEN H. JOHNSON	JUDGE FROM SCHENECTADY		JANUARY 4, 1865
DAVID P. FORREST	PRISON INSPECTOR		JANUARY 1, 1868
HENRY C. NELSON	POLITICIAN FROM SING SING VILLAGE		JANUARY 19, 1869
E. M. RUSSELL	BOOKEEPER		FEBUARY 10, 1870
HENRY C. NELSON			JANUARY 10, 1872
GAYLORD B. HUBBELL			JANUARY 1, 1873
JAMES WILLIAMSON			SEPTEMBER 12, 1874
ALFRED WALKER	CONTRACTOR		OCTOBER 6, 1874
GEORGE R. YOUNGS	CLERK		JANUARY 15, 1876
B. S. W. CLARK	CIVIL ENGINEER 11/16- CLOSED THE WOMANS PRISON, HAD THE WALL BUILT		MARCH 22, 1877
CHARLES DAVIS	BUISNESS MAN FROM BINGHAMTON HAD 10 ' IRON FENCE BUILT ALONG THE RIVER		FEBRUARY 16, 1878
AUGUSTUS A. BRUSH	REVENUE COLLECTOR FROM FISHKILL, " THE PHARAOH OF SING SING WARDENS "		APRIL 1, 1880
W. R. BROWN	POSTMASTER FROM NEWBURGH DIRECTED THE FIRST ELECTROCUTION		MAY 1, 1891
CHARLES F. DURSTON	WARDEN FROM AUBURN DIED OF TYPHOID 10/12/94		MAY 1, 1893
OMAR V. SAGE	COAL DEALER FROM CATSKILL		OCTOBER 14, 1894
ADDISON JOHNSON	HORSEMAN FROM PORT CHESTER		MAY 1, 1899
JESSE D. FROST	TRANSFER TAX APPRAISER & DISTRICT LEADER FROM BROOKLYN		JULY 22, 1907
JOHN S. KENNEDY	NEW YORK POLICEMAN		JULY 19, 1911
*JAMES CONNAUGHTON	PRINCIPAL KEEPER		JUNE 5, 1913
JAMES M. CLANCY	ACCOUNTANT FROM THE BRONX		JULY 9, 1913
THOMAS McCORMICK	STEAMFITTER FROM YONKERS PERMITTED GOLDEN RULE BROTHERHOOD		JUNE 22, 1914
*GEORGE WEED	LAWYER FROM PLATTSBURG		OCTOBER 28, 1914
THOMAS MOTT OSBORNE	MILLIONAIRE	MUTUAL WELFARE LEAGUE	DECEMBER 1, 1914
GEORGE W. KIRCHWEY	COLLEGE PROFESSOR	ESCAPE OF ORESTA SHILLITANO FROM C.C.	DECEMBER 31, 1915
THOMAS MOTT OSBORNE			JULY , 1916
CALVIN DERRICK	SCHOOL TEACHER		OCTOBER 16, 1916
WILLIAM H. MOYER	WARDEN FROM ATLANTA PENITENTIARY		DECEMBER 11, 1916
EDWARD V. BROPHY	JUDGE & TRANSFER TAX APPRAISER FROM PORT CHESTER		APRIL 15, 1919
*DANIEL J. GRANT			DECEMBER 16, 1919
LEWIS E. LEWES			JANUARY 1, 1920
ROBERT J. KIRBY			JULY 7, 1941
WILLIAM E. SNYDER			JANUARY 24, 1944
WILFRED L. DENNO			DECEMBER 31, 1950
JOHN T. DEEGAN			JANUARY 27, 1967
JAMES L. CASSCLES			AUGUST 1969
THEODORE SCHUBIN			MARCH 1972
*JOSEPH HIGGINS			JULY 1975
HAROLD BUTLER			OCTOBER 1975
WILLIAM G. GARD			NOVEMBER 6, 1975
*WALTER FOGG			AUGUST 1977
STEPHEN DALSHEIM			AUGUST 22, 1977
WILSON E. J. WALTERS			JULY 24, 1980
JAMES E. SULLIVAN			JUNE 23, 1983
JOHN P. KEANE			DECEMBER 1, 1988
CHARLES GREINER			MARCH 13, 1997
BRIAN S. FISCHER			MAY 4, 2000

*ACTING WARDEN / SUPERINTENDENT

This list of wardens at Sing Sing Prison includes their previous occupations and highlights during their terms.

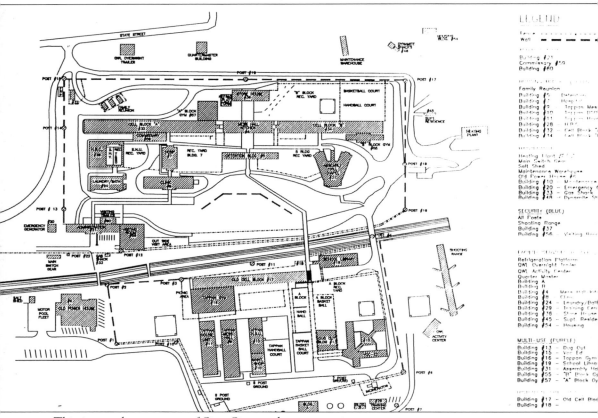

This image shows a map of Sing Sing at the present time.